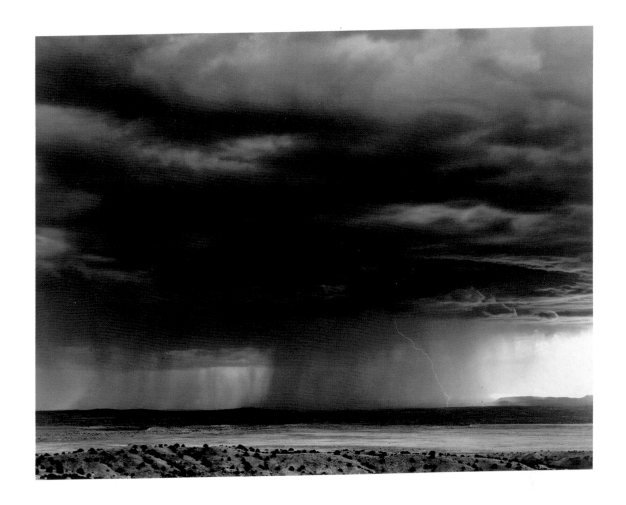

# LAND, SKY, AND ALL THAT IS WITHIN

VISIONARY PHOTOGRAPHERS IN THE SOUTHWEST
JAMES L. ENYEART

MUSEUM OF NEW MEXICO PRESS
SANTA FE

FOR ROXANNE MALONE
ARTIST AND FELLOW WORKER IN THE VINEYARD

Copyright © 1998 Museum of New Mexico Press. Photographs by Ansel Adams courtesy of Ansel Adams Publishing Rights Trust. Photographs by John Collier, Jr. and Russell Lee courtesy of the Library of Congress. Photographs by Laura Gilpin © 1979 Amon Carter Museum, Fort Worth, Texas, Bequest of Laura Gilpin. Photographs by Eliot Porter © 1990 Amon Carter Museum, Fort Worth, Texas, Bequest of Eliot Porter. Photographs by Paul Strand: *Near Abiquiu, New Mexico*, 1930 © 1981 Aperture Foundation Inc., Paul Strand Archive; *Window, Red River, New Mexico*, 1931 © 1982 Aperture Foundation Inc., Paul Strand Archive; *Grazing Horses, Taos, New Mexico*, 1930 © 1982 Aperture Foundation Inc., Paul Strand Archive; *St. Francis Church, Ranchos de Taos, New Mexico*, 1930 © 1981 Aperture Foundation Inc., Paul Strand Archive. Photographs by Willard Van Dyke © 1986 The Estate of Willard Van Dyke. Photographs by David Vestal © 1966 David Vestal. Photographs by Todd Webb © Todd Webb. Photographs by Brett Weston © Brett Weston Archive. Photographs by Edward Weston © 1981 Center for Creative Photography, Arizona Board of Regents Collection, University of New Mexico Art Museum. *All rights reserved.* No part of this book may be reproduced in any form or by any means whatsoever, except for brief text passages embodied in critical reviews, without the expressed written consent of the publisher and copyright holder.

The title "Land, Sky, and All That Is Within" is adapted from a phrase in Leslie Marmon Silko's essay "Landscape as Myth and Memory," published in *Landscape in America*, George F. Thompson, ed. (Austin: University of Texas Press, 1995) 157. Used with permission.

Project editor: Mary Wachs
Design and production: David Skolkin
Composition: Set in Sabon with Stone Sans display.

Manufactured in Italy
10  9  8  7  6  5  4  3  2  1

Library of Congress Cataloging-in-Publication Data
Enyeart, James.
    Land, sky, and all that is within : visionary photographers in the Southwest /
by James L. Enyeart.
       p.   cm.
    ISBN 0-89013-366-2 (c). —!SBN 0-89013-365-4 (p)
    1. Photography—Southwestern States—History—19th century—Exhibitions.
    I. Title.
    TR23.9.E59   1998
    779'.3679—dc21
                                                    98-4202
                                                    CIP

# Contents

New Mexico has attracted photographers, photographic historians, and writers on photography since its earliest days as an artistic and cultural center. There are many reasons why this area, rich in natural beauty and spectacular land formations, has attracted these individuals. The most obvious is that it so naturally fulfills photography's reliance on the physical world and light for the creation of imagery.

Since the earliest days of the region's development as a center for photographic activity, New Mexico stood out as a destination. In the latter part of the nineteenth century and early twentieth century we find Edward Curtis and Charles Lummis working here. Later, we see Paul Strand, the landmark works of Brett Weston at White Sands, and Ansel Adams's icon "Moonrise over Hernandez." Contemporary photographers like Betty Hahn, Meridel Rubenstein, and Walter Chappell have made their home here and have accepted the influence of the place in their work as well. Eliot Porter, Paul Caponigro, and William Clift also are among the photographers that New Mexico claims as its own. Among the most notable writers, scholars, and historians who made New Mexico their home are Nancy and Beaumont Newhall and Van Deren Coke. These individuals with their far-reaching

ideas provide scholarship and inspiration to photographers and photographic audiences globally. Likewise, Steve Yates, curator of photography at the Museum of Fine Arts, continues to demonstrate the community's commitment to photography through innovative exhibitions and intelligent collecting.

As we approach the end of the century and a true revolution in the medium of photography from both a technological and expressive point of view, the Museum of Fine Arts wishes to take a fresh look at this medium's activity and influence on the region. With this important task at hand, we were fortunate in having James Enyeart agree to mount the exhibition "Land, Sky, and All That Is Within: Visionary Photographers in the Southwest" James Enyeart joins the ranks of major American figures in photography who have settled in New Mexico, and through this exhibition and publication he brings to us his vast knowledge and insight into the medium. We are thankful for his contribution to the museum and the artistic community.

The Museum would like to acknowledge a generous donor, who wishes to remain anonymous, whose support of this exhibition and the three others that preceded it in the series enabled the museum to achieve its aim of expanding the interpretation of photographic activity in this century.

Mary Wachs, editorial director of Museum of New Mexico Press, provided guidance and enthusiasm throughout the entire process. David Skolkin, art director, gave us his expertise and keen judgment in the design and production of this publication, and Kerry Boyd, director of exhibitions, and John Tinker effectively designed the installation of the works.

This exhibition and publication would not have been possible without the assistance of Joan Tafoya, registrar at the Museum of Fine Arts. Marianne Fulton, Jim Conlin, Therese Mulligan, Janice Madhu, Barbara Galasso, and David Wooters at the George Eastman House provided invaluable assistance. Kathleen Howe of the University of New Mexico Museum of Fine Art provided scholarly encouragement and has our appreciation. Terence Pitts, Marsha Tiede, Diane Nilsen, and Claudine Scoville from the Center for Creative Photography at the University of Arizona contributed to research and development of the project. The Andrew Smith Gallery and Scheinbaum and Russek Limited provided key loans to the exhibition. The College of Santa Fe provided invaluable assistance through a group of energetic curatorial assistants: Summerlynne Bartlett, Nicole Cote, Hillary Maher, Rita Minor, Sonia Riback, Stephen South, and Wendy Young.

ix

The following individuals and organizations provided reproduction permissions and have our gratitude: The Paul Strand Archive; The Ansel Adams Publishing Rights Trust; The Amon Carter Museum (for Eliot Porter and Laura Gilpin); The Center for Creative Photography (for both the Brett Weston and Edward Weston Estate); Mrs. Willard Van Dyke; The Library of Congress (for Russell Lee and John Collier, Jr.); David Vestal; and Betsy Evans (for Todd Webb).

Finally, I would like to acknowledge these artists who are landmarks in the study and appreciation of photography in the region and beyond.

— STUART A. ASHMAN,
*Director, Museum of Fine Arts*

THIS BOOK, AND the exhibition it accompanies, offers a new way of looking at photographs made by a select group of visionary photographers who worked in the Four Corners region (Arizona, Colorado, New Mexico, Utah) between 1870 and 1970. It is a period in which there was a particularly concentrated influx of photographers with aesthetic intent. Artists in every sense of the word, these photographers allowed their artistic intentions to be acted upon by the region's dramatic landscape and its unique cultural ambience. As a result, their ideas about art and the photographs they made were altered in significant ways. Their photographs, often of the same subject photographed decades apart, have visual similarities that defy time and resist outside influences. It is not that they were captivated by the environment in aesthetically slavish ways but that their works of art both emanate from a common poetic essence that is a reflection of the spirit of the region and simultaneously serve as icons of the region. As a result, we tend to think of the Four Corners not in terms of how it looks but how it ought to look according to the visions of these artists and the lasting impressions of their visual legacies.

Numerous books and essays about the era of exploration in the West, including the Southwest, have presented a historical trail of events and biographical accounts of those involved.[1] But I have

endeavored to provide here a different perspective: first, by erasing the boundaries that define geographic areas and instead treating the region as a whole and, second, by suggesting that its most defining and characteristic attributes, traceable through art, are essentially philosophic and aesthetic.

The essay that follows is a philosophic inquiry into the nature of the images rather than a history of their creation. I have used artistic criteria to probe the relationships between documentation and interpretation, visual pleasure and philosophy, reflections and refractions of reality. The achievements of these photographers will be looked upon, then, more according to the nature of the artworks produced than in terms of their placement in history. The impact of the region on these artists' works and, in turn, their impact on the art world at large is a complex story that continues to be played out in contemporary notions about modernism and postmoderism.

History, criticism, collecting, and exhibitions are societal enhancements of works of art that expand and develop audiences, preserve and care for the best, and analyze their social significance. But in terms of a work of art itself, none of these enhancements are requisite to the creative process nor do they exist without the artist. The majority of the photographs included in the exhibition were not initially aided by such enhancements. In the purest sense of the idea, their photographs were cre-

ated under circumstances that are more like the works of indigenous cultures, whose ceremonial and religious motives are nonetheless given over to aesthetic and visual pleasure. The motives of the photographers were based on the same kind of artistic intuition and were less influenced by the potential rewards of mainstream art and society. In light of this circumstance, the following essay explores the shadowed world of aesthetic intent as the essential ingredient of the works presented.

<div style="text-align: right">J. E.</div>

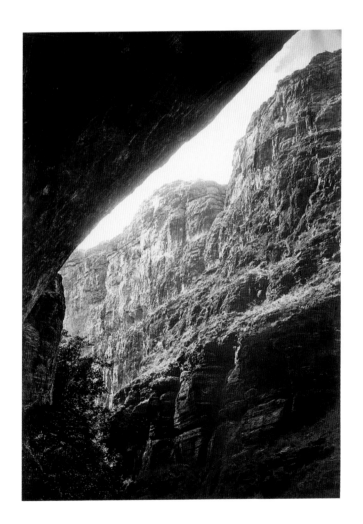

xvi

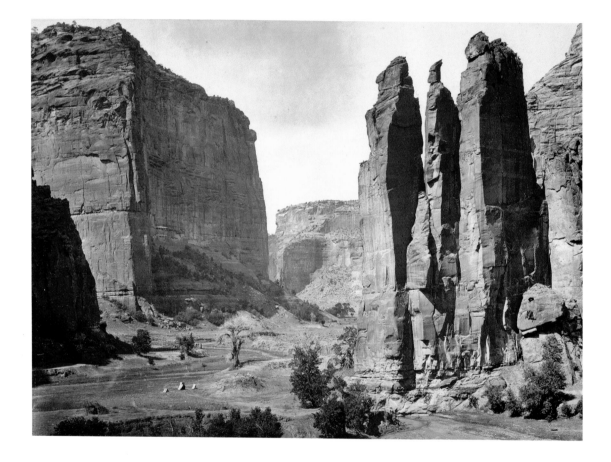

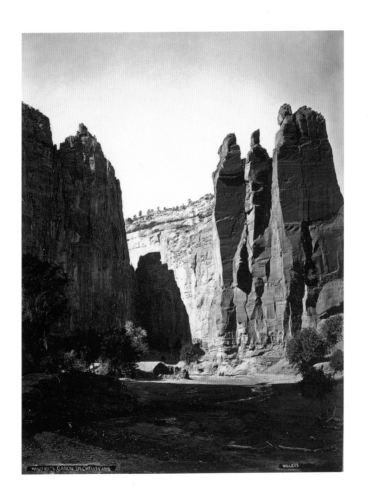

xviii

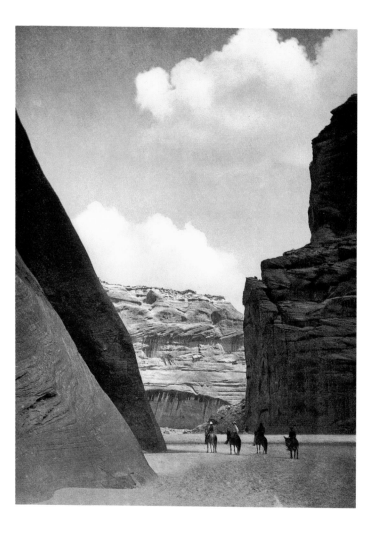

ment of their efforts, using artists of various media to proclaim their worth. In the twentieth century, with the acceptance of photography's role in the art world firmly established, self-assigned explorations offered an expanded sense of the nature and character of the region. During these one hundred years, the two major deficits of involvement in the artistic record are women and minority photographers, who had scant opportunity to participate. After 1970, however, both gender and cultural diversity of photographers are more equitably represented in the continuing fascination with the region.

Photographers drawn to the Four Corners area developed as a special class of visual poets, an elite group that expressed and revealed a spiritual connection to its subjects that went far beyond mere description. The place they explored as such was not just the subject before their lens but another kind of place, a place within. These artists' works were not just inspired by the dramatic nature of their surroundings. Something more was evident, something subjective and intangible. Within the interior of their artistic being, deep in the recesses of their emotional fabric, there grew a seed of understanding that precipitated works of unusual merit and vision, perhaps the best work of their careers. When they traveled and made photographs across the region they no longer seemed to be seeking fulfillment of an earlier style but happened upon rare manifestations of the spirit of

place with a remarkable and surprising consistency. As they increasingly interacted with an ethereal landscape of mystical formations, atmospheric effigies, tormented mountains, ancient color palettes, and peoples uniquely subsumed in the whole, the true character of the region evolved in their psyches, pushing aside otherwise predominant Eurocentric notions of reality and existence. Also pushed aside was the reliance upon painters for verification of artistic ideals. Late-nineteenth-century photographers of certain irrefutable artistic drives were intuitively brave trusting their medium to give new meaning to the definition of art. The intuition that these photographers held, their self-confidence that their images were more than mere evidence of grandeur, placed them within the realm of the arts of their own time. "It is the artist's task to remove obstacles that stand between his audience and the events he describes," wrote anthropologist Edward T. Hall. "In so doing, he abstracts from nature those parts which, if properly organized, can stand for the whole and constitute a more forceful, uncluttered statement than the layman might make for himself. In other words, one of the principal functions of the artist is to help the layman order his cultural universe."[3]

The photographs of interest here, made between 1870 and 1970, encompass two artistic periods, which are generally seen as devoid of social relevance—romanticism and modernism. But if

these photographers were reacting to the very soul of a unique place, as is asserted, then it will have to be demonstrated that perhaps no work of art can be isolated from social context. This would suggest that contemporary notions of deconstruction, appropriation, and political correctness are but veiled means of recycling much older issues for artists of beauty, subjectivity, visual pleasure, and meaningful content. If, by the apprehension of elegant form, modernist photographers were making an appeal in opposition to an inelegant society or if by the first romantic nineteenth-century landscapes a grander future was envisioned than reality provided, then the issue of social relevance may be put aside in favor of discovering visual agendas of works of art in their own time.

JOHN K. HILLERS, CA. 1875
**GRAND CANYON**

right
JOHN K. HILLERS, CA. 1875
**GRAND CANYON, ARIZONA**

8

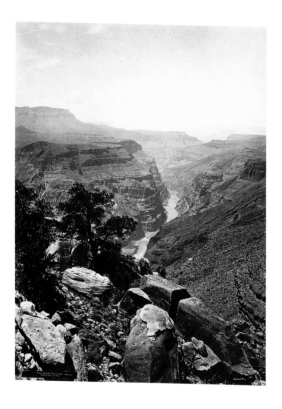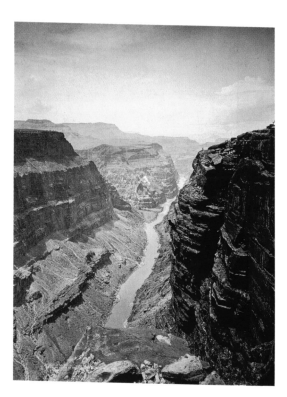

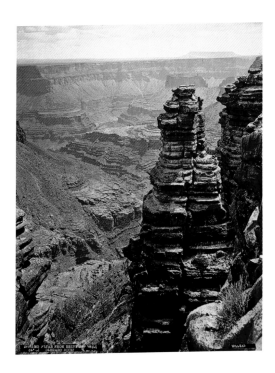

JOHN K. HILLERS, CA. 1875
**MARBLE CAÑON, COLORADO RIVER**

below
JOHN K. HILLERS, 1873
**PARUNUWEAP CANYON, VIRGIN RIVER VALLEY, UTAH**

9

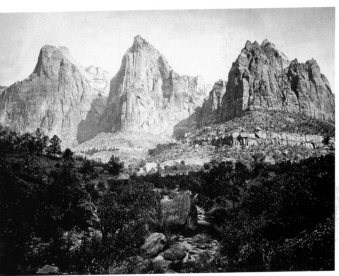

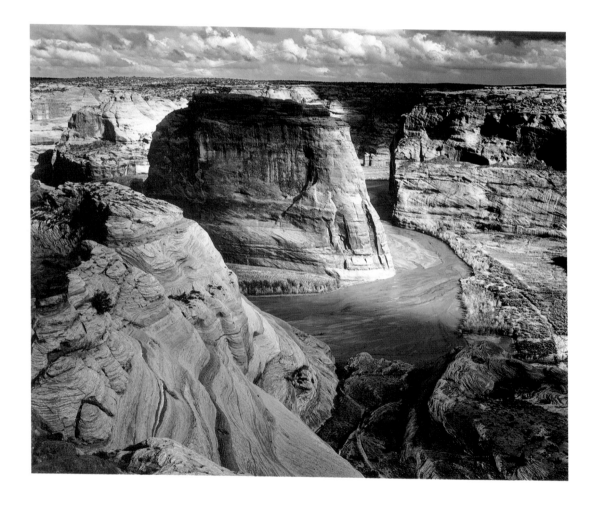

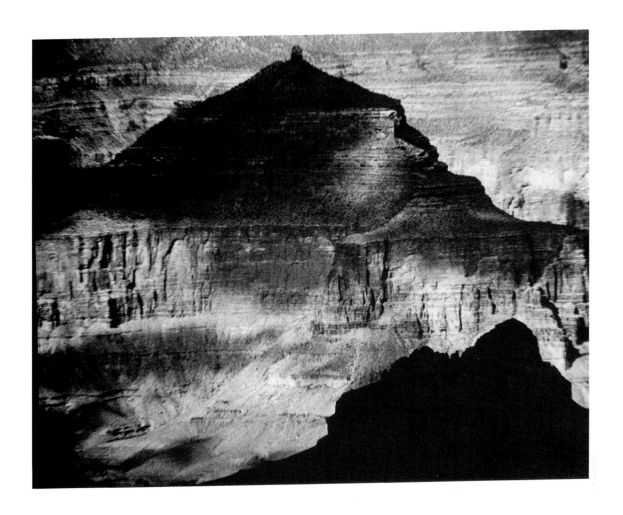

12

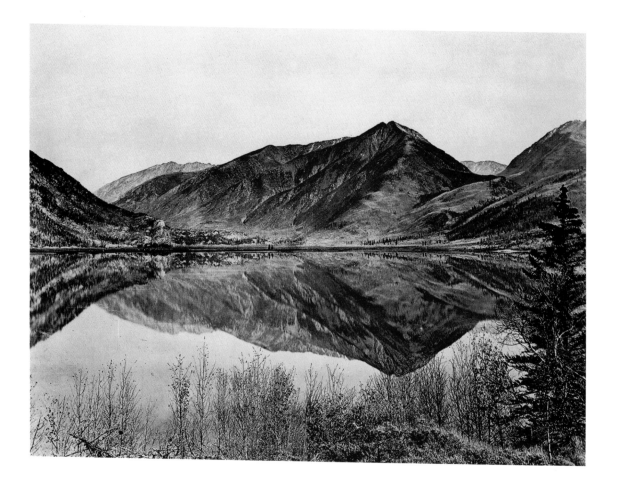

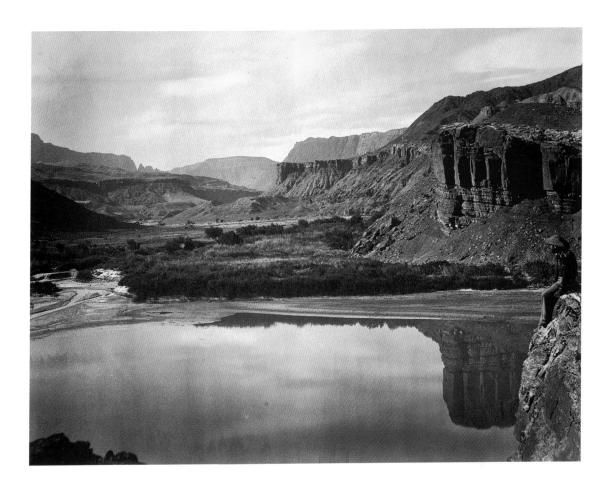

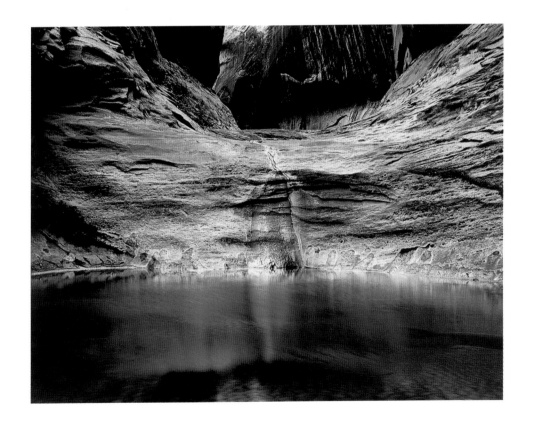

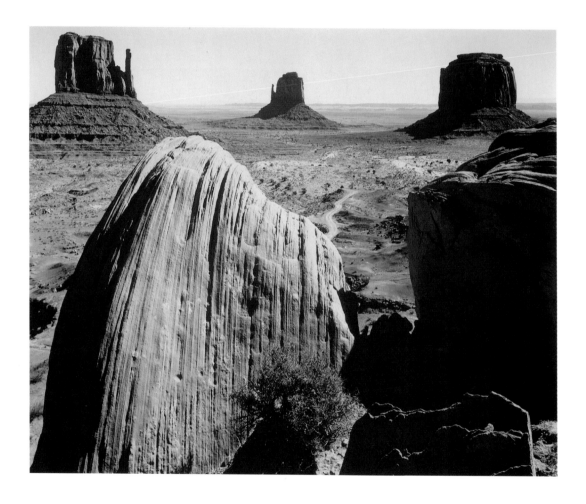

16

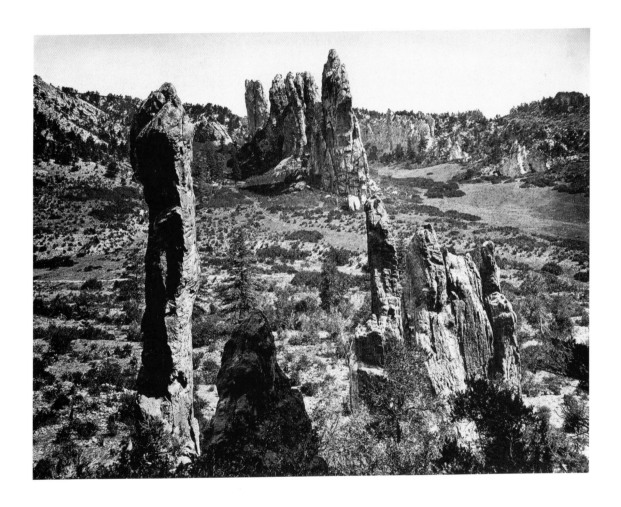

18

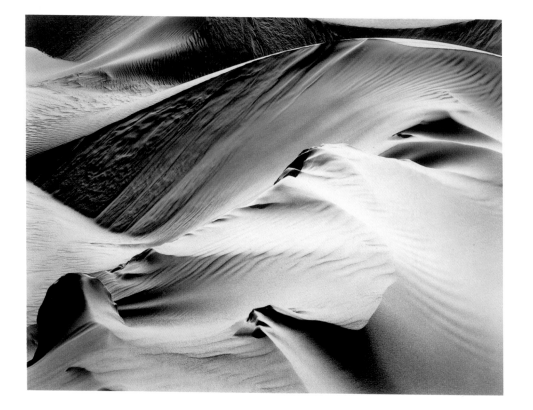

Just as it is an accepted axiom that we can only see the present in light of the past, so it is true that we can often only appreciate the past in light of the present. The photographers who first interacted with the Four Corners area arrived with certain embedded influences but also with characteristics universal to artists that served to balance these predispositions. Etienne Gilson, one of the most eloquent spokesmen in our own time on such universal traits to be found in artists, helps to clarify the artistic mind-set of the nineteenth century by describing the artist without reference to time or period. His ruminations on the artist come close to the way many artists would define themselves, especially photographers, who have always been in constant engagement with the notion of reality. He said of artists that they are "that particular breed of people who do not find in nature a certain class of objects that ought to be there."[4] His writings place artists in the overall scheme of human existence as an extension of nature itself yet, interestingly, his views about art were first posited in the middle of the twentieth century, a time when the art world was more concerned with the language of art than with the artist's place in the hierarchy of the arts. Just as the pressures of an expanding social agenda were impacting nineteenth-century photographers brought west with

territorial expansion, so too the artists of the 1960s were being acted upon by the extremes of that period. An investigation of the linguistic concerns of art and criticism at the time would reveal the beginning of social conscience as the prime concern of the arts, which led eventually to the cynicism of postmodernism—art as critic—and to today's socially narrative works disguised as objects ironically more decorative than even the most egregiously pictorialist works of a century earlier.

While there are many who ponder the inner workings of artists' minds, it was Arthur Schopenhauer's interest in the intersection of art and nature that especially influenced, in an indirect way, nineteenth-century photographers of the American Southwest. Despite his remoteness from mainstream analysis of artists and nature, his ideas on the subject serve to temper the extreme nationalism, if not downright provincialism, that so often accompanies such histories. Schopenhauer theorized that in order for humanity to come to terms with life, it must conquer desire or self-perception through contemplation of the will, which is manifest in the arts and philosophy. Thus reality may be perceived objectively. In his elevation of the primacy of the arts, which provide an anecdote to the suffering brought on by self-consuming desires, his philosophy did much to influence later authors such as Santayana (*The Sense of Beauty*) and to condition the romanticism, with

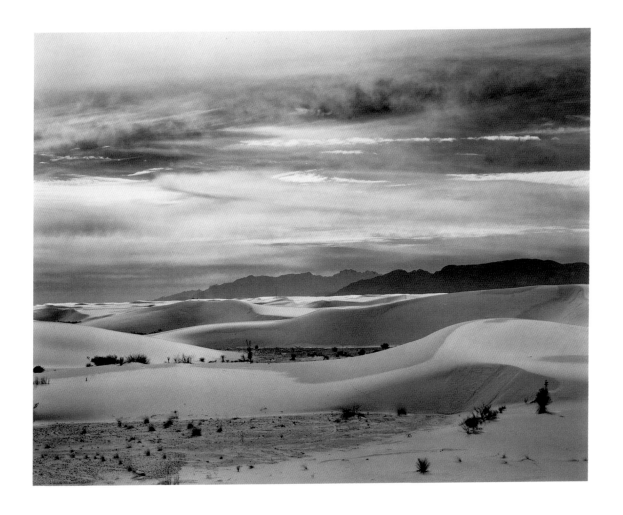

its resultant ethereal belief in art's powers of transformation. Many of the terms he used are also to be found in the writings of American thinkers such as William Cullen Bryant and Ralph Waldo Emerson and in the works of the American painters and photographers Thomas Moran, William Henry Jackson, and Edward Weston, among others.

Jackson and Moran worked under the philosophical mantle of the sublime in nature, and Weston and other modernists identified with the thing itself and significant representation of form, ideas inherent in the aesthetic terms set forth by Schopenhauer: "Intelligence and matter are correlates, i.e. one exists only in the other . . . and this one thing . . . is the manifestation of the will, or the thing in itself."[5] As long as aesthetic contemplation is "merely" beauty affecting us, posits Schopenhauer, we are not free even from the will itself. In searching for a condition to free us from such aesthetic awareness, Schopenhauer sets in motion the idea of the sublime, which was the dominant vision for artists who explored the Southwest: "But if these very objects whose significant forms invite us to pure contemplation, have a hostile relation to the human will in general, as it exhibits itself . . . , so that it is menaced by the irresistible predominance of their power, or sinks into

insignificance before their immeasurable greatness; . . . comprehends only their idea, which is foreign to all relation, so that he [the artist and/or the viewer] lingers gladly over its contemplation, and is thereby raised above himself, his person, his will, and all will:—in that case he is filled with the sense of the sublime, his is in the state of spiritual exaltation, and therefore the object producing such a state is called sublime."[6]

Schopenhauer was preceded by Edmund Burke, an eighteenth-century Irish statesman and writer who, as Estelle Jussim observed, "decided that there were specific and definable characteristics of landscape which he noted as the sublime, differentiating them from the merely beautiful."[7] Influenced by these philosophers, and more directly by Wordsworth, Coleridge, and others, the stage was set for the former Unitarian minister Ralph Waldo Emerson to become the foremost spokesman for transcendentalism in the emerging American consciousness. Emerson's writings on the spiritual qualities in art and nature exerted significant influence on the early landscape painter Thomas Cole and his successor, Thomas Moran. Cole and the Hudson River School, which included Alfred Bierstadt, Asher B. Durand, and George Inness, adapted European romanticism to American painting.

With the poetic infusion of Emerson's essays and the poetry of William Cullen Bryant, the deification of nature and nature's purpose was made available to the artists who would endure the hardships and danger of westward exploration, especially the Southwest.

Emerson described nature as "these plantations of God,"[8] and Bryant's poem, "Forest Hymn," included the phrase "The groves were God's First Temple," which directly correlated to Moran's 1867 painting *The Woods Were God's First Temple*. The desire to connect nature, God, and humankind is found nowhere more explicitly than in the life and poetry of William Wordsworth, whose influence on American artists, naturalists, and writers cannot be overstated, especially given his democratic agenda, which brought him disdain among critics in his own country:

*I heard a thousand blended notes,*
*While in a grove I sate reclined,*
*In that sweet mood when pleasant thoughts*
*Bring sad thoughts to the mind.*

*To her fair works did Nature link*
*The human soul that through me ran;*
*And much it grieved my heart to think*
*What man has made of man.*[9]

TIMOTHY H. O'SULLIVAN, 1874
**THE COLORADO RIVER
AT THE MOUTH OF PARIA CREEK**

Thus by 1870, the preparation for government-sponsored artists, particularly photographers, was complete with ready-made aesthetic philosophies for how an image should transcribe nature in human and spiritual terms. If the geological surveys were explorations of exploitable resources, they were also evidence of the sublime theological reinforcement of nature's reminder of God's presence, especially when the grand tableau of the Southwest spoke with such drama and ecclesiastical solitude. In the face of such imaginative representations as the paintings of Moran, which were intended to release emotions equivalent to rapture, photographs brought a sense of reality and veracity that erased any doubt about artistic license and the scale and degree of the unimaginable landscape of the Southwest. The photographers who previsioned their images within this philosophical framework had an additional burden or opportunity, as the case might have been. Just by virtue of the documentary nature of the photographic medium, and regardless of the photographer's selective vision and monochromatic abstraction of nature, the public received the photographs as more truthful and believable than the works of their fellow painters.[10]

It was not without design that the organizers of the surveys took along artists and photographers whose reputations for aesthetic truthfulness to nature accorded with their own views. Clarence

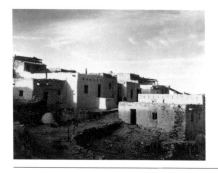

WILLARD VAN DYKE, 1933
**LAGUNA, NEW MEXICO**

King, for example, led the 1867 government expedition along the Fortieth Parallel to record the landscape in scientific detail, but his allegiance was to art as well as science. As one of the founders of The Society for the Advancement of Truth in Art, King was able to further his personal cause through the works of the photographer he brought along, T. H. O'Sullivan. Founded during the Civil War, in 1863, the society endorsed the tenets of Ruskin, Emerson, and the Transcendentalist movement, but with the added caveat that the image of nature created by the artist must exclude "change or disguise."[11]

Photographers also learned from and were influenced by other photographers, especially in terms of the potential of their medium. It is a record of history that Carleton E. Watkins, the premier photographer of Yosemite, produced images of such extraordinary aesthetic intentionality that no photographer who expected to expand his interest in landscape would have missed seeing Watkins's works on exhibit.

The description of landscape, in particular that of New Mexico, by Leslie Marmon Silko, contemporary poet and writer, comprehends the timelessness of the region represented by the artists in this book. Her insights engendered by her upbringing at Laguna Pueblo brings into context the

deeper and more intrinsic connectedness of all the elements of landscape as a prime factor in the implied power of this region and its significant impact upon, if not actual cause for change in the visions of the artists represented: "The land, the sky, and all that is within them—the landscape—includes human beings. Interrelationships in the Pueblo landscape are complex and fragile. The unpredictability of the weather, the aridity and harshness of much of the terrain in the high plateau country explains in large part the relentless attention the ancient Pueblo people gave to sky and the earth around them. Survival depended upon harmony and cooperation not only among human beings, but also among all things. . . ."[12]

Silko's description of the landscape as a fragile complex of interrelationships between humanity and nature reiterates the underlying connection that helped to mold the visions of artists of the region. But, since artists do not work in a vacuum, unrelated to the pressures and influences of society, it is worth mentioning that the nineteenth-century photographers attracted to this extraordinary landscape and culture also were envisioning the region within the context of a number of less than sublime sociological events. The completion of the Pacific transcontinental railroad in 1869 launched an aggressive cattle industry; the marketing of photographs in the Civil War led to a pub-

lic appetite for merchandising of the new art that equaled private and government collecting of panoramic paintings; acculturation and relocation of Native American tribes on reservations contradicted the romantic idea of indigenous harmony of the landscape; discovery of precious mineral deposits in the Rockies brought ravenous destruction; the Mormon migration to Utah led settlements in the region; and Zebulon Pike's earlier description promulgated images of the region as the "Great American Desert." All of these forces combined to provide a background that only intensified the artistic zeal for images of paradise as reflected in the idea of art and nature—the essential unity, both philosophically and aesthetically, that gave photographers their first equal footing with dominant art forms in the American art scene.

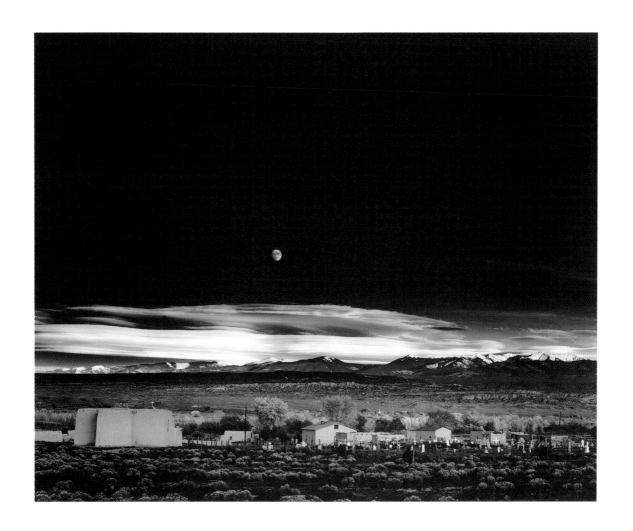

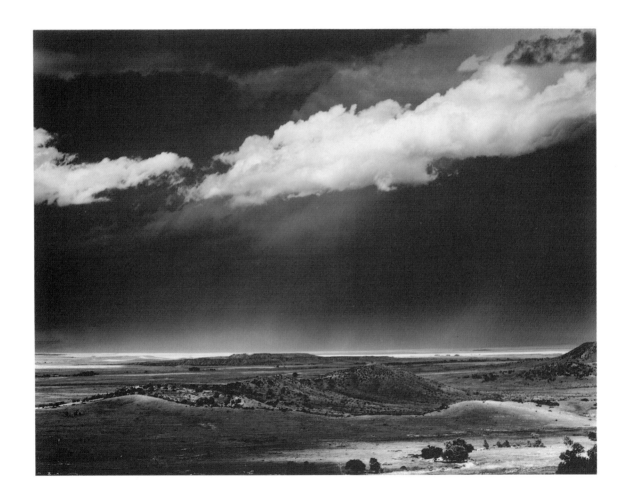

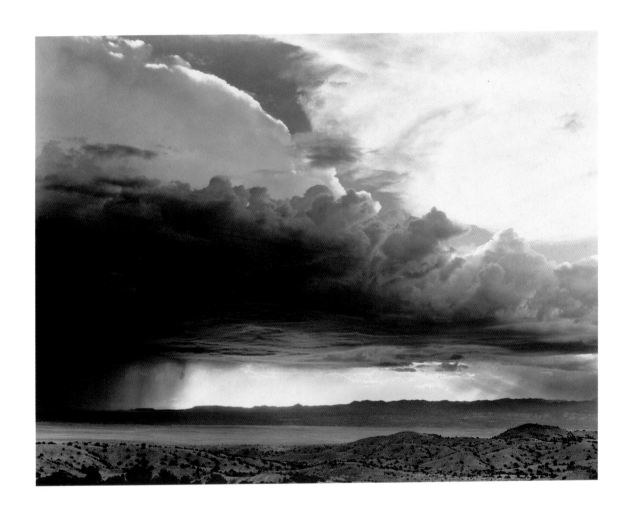

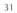

32

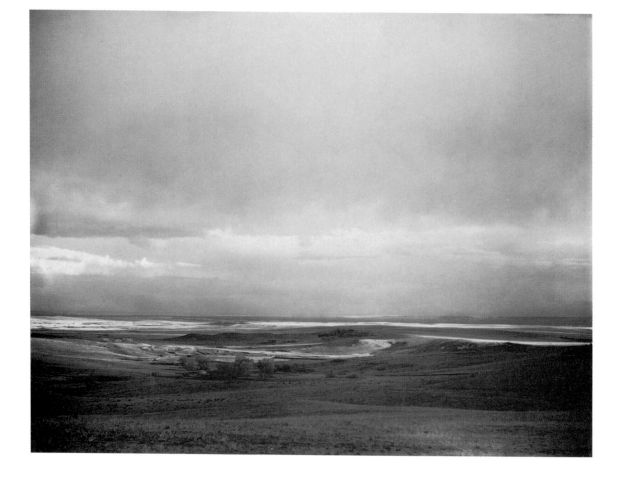

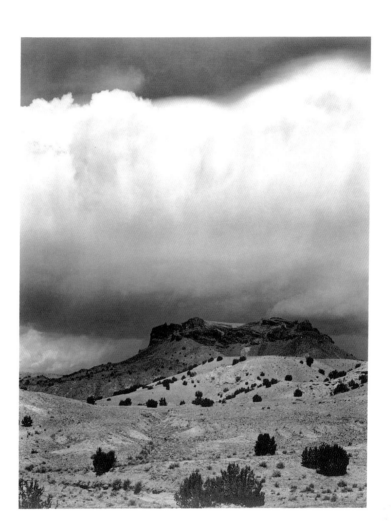

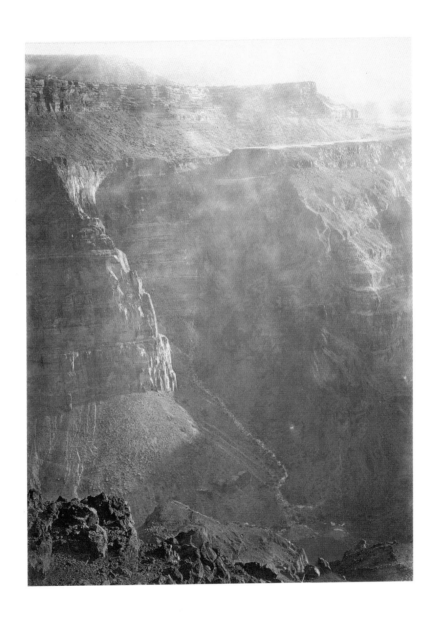

36

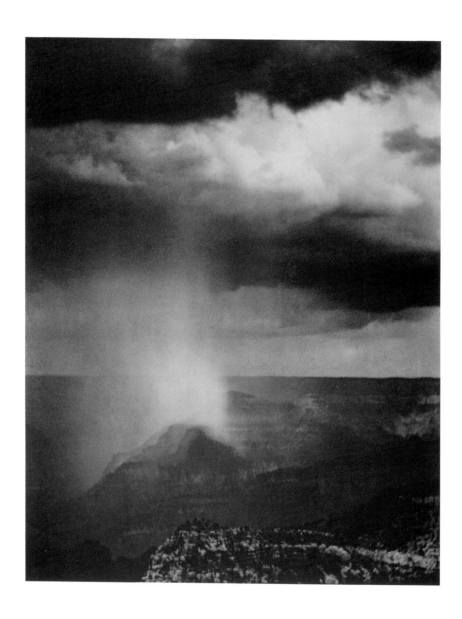

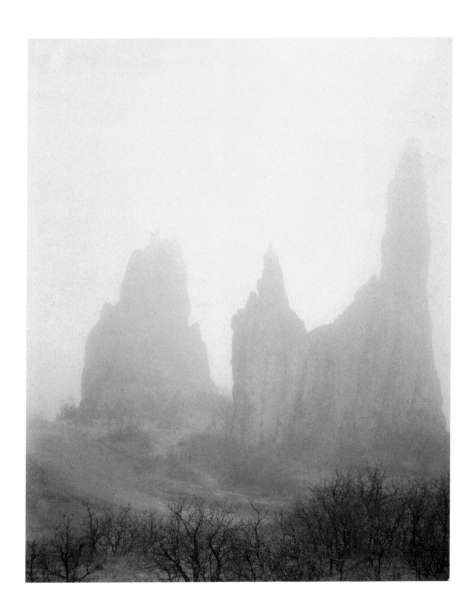

38

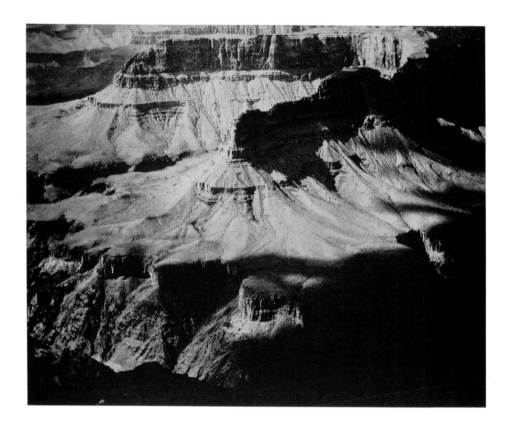

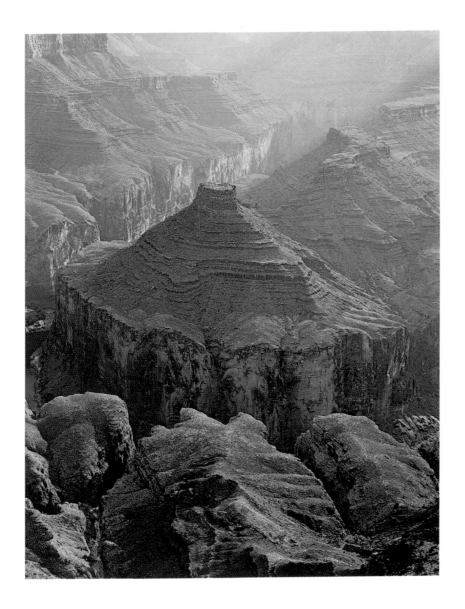

TIMOTHY H. O'SULLIVAN, 1873
**CAÑON DE CHELLEY, ARIZONA**

right
ANSEL ADAMS, 1942
**WHITE HOUSE RUIN,
CANYON DE CHELLEY NATIONAL MONUMENT**

40

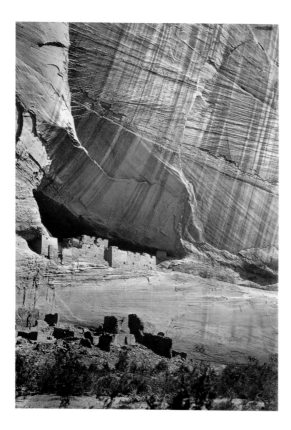

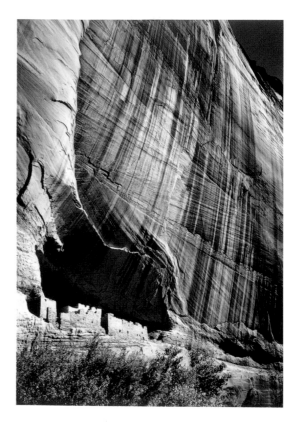

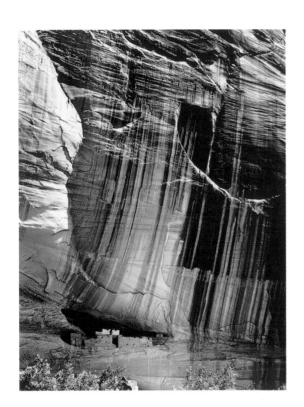

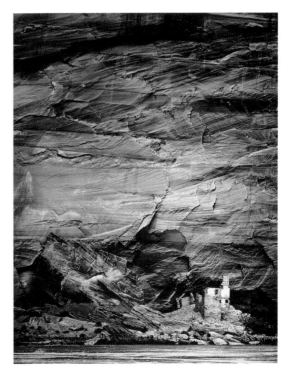

LAURA GILPIN, 1930
**RANCHO DE TAOS, NEW MEXICO**

below
ANSEL ADAMS, CA. 1932
**REAR, RANCHOS DE TAOS CHURCH,
NEW MEXICO**

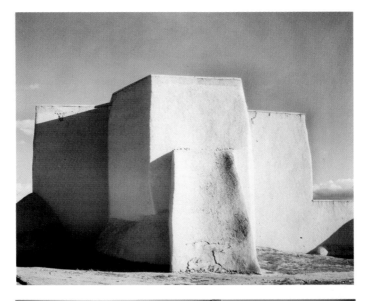

42

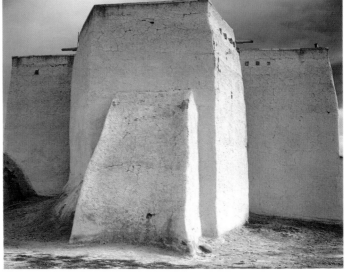

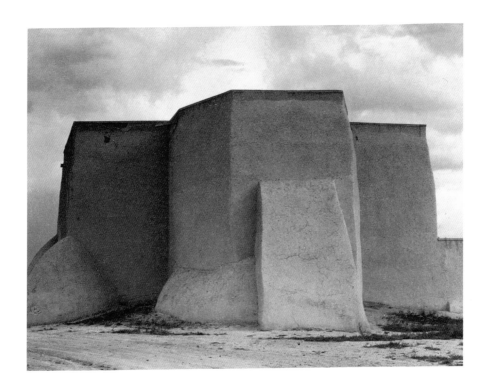

44

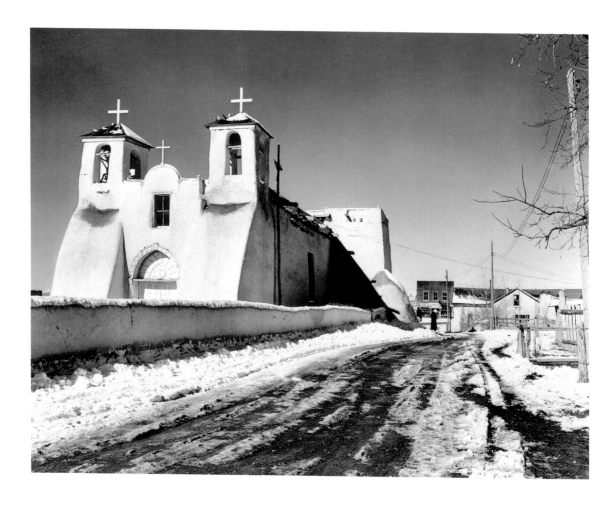

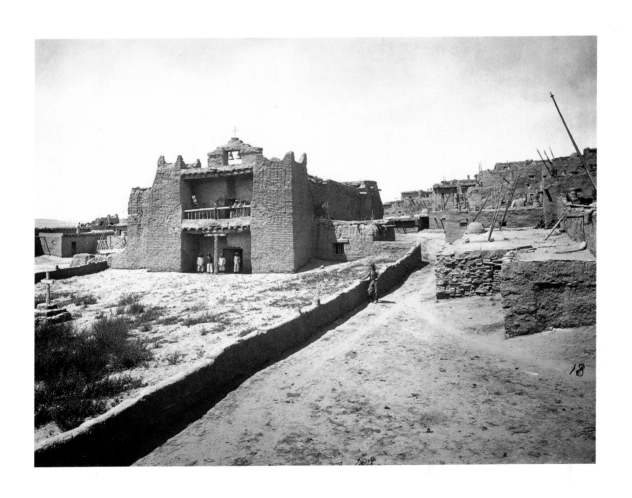

45

46

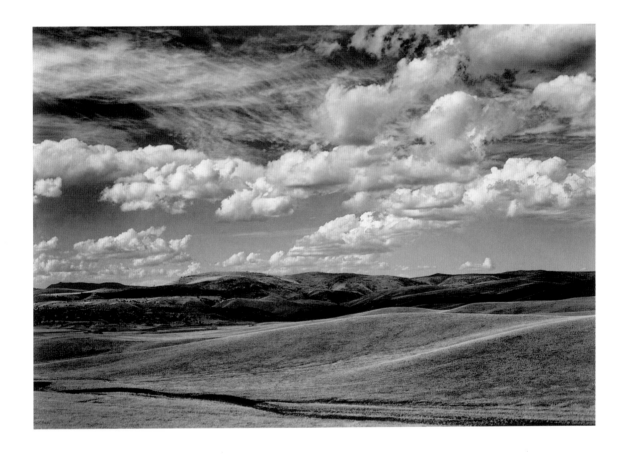

48

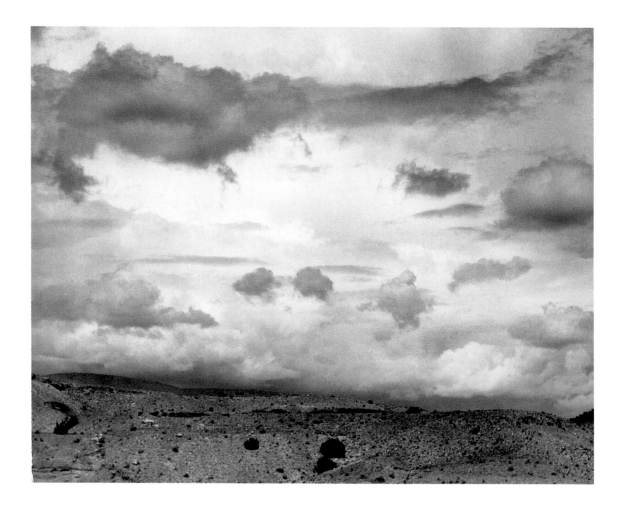

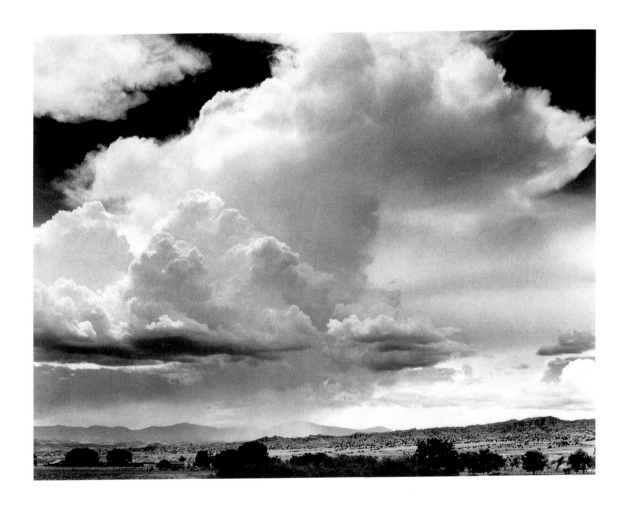

50

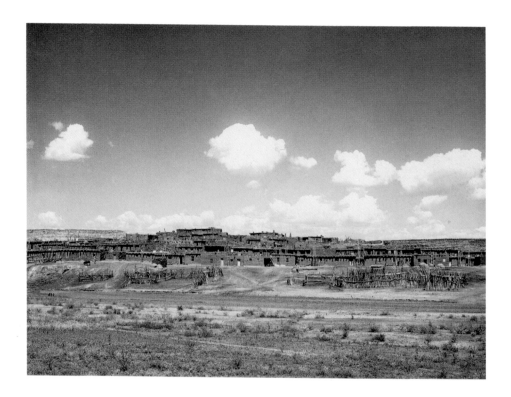

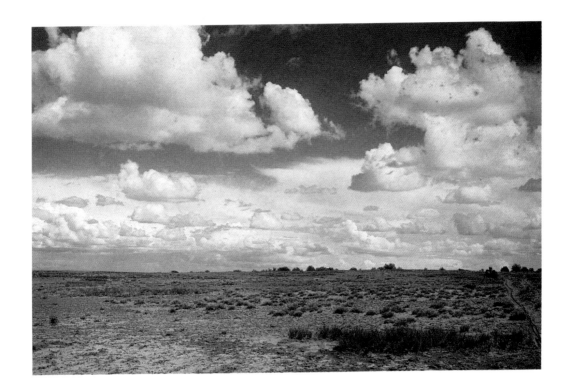

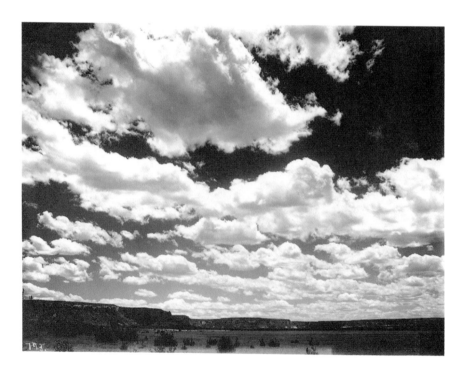

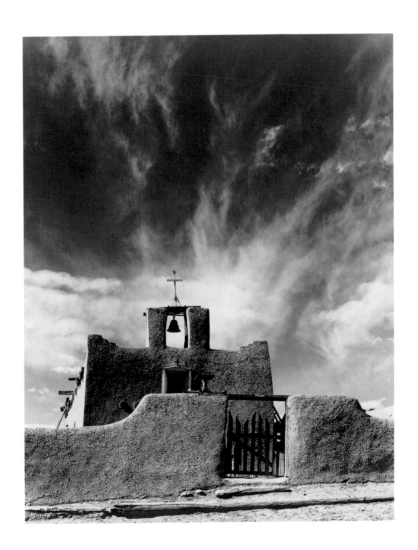

54

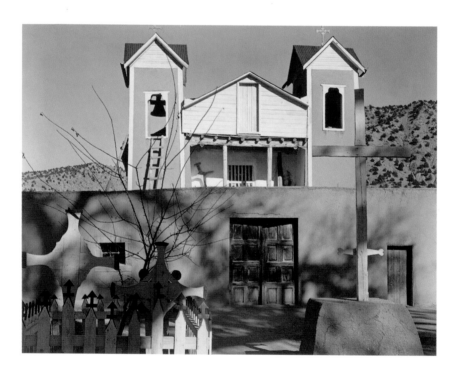

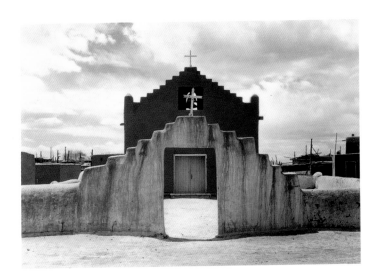

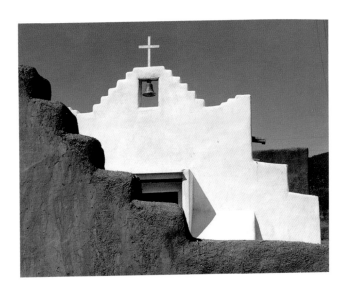

56

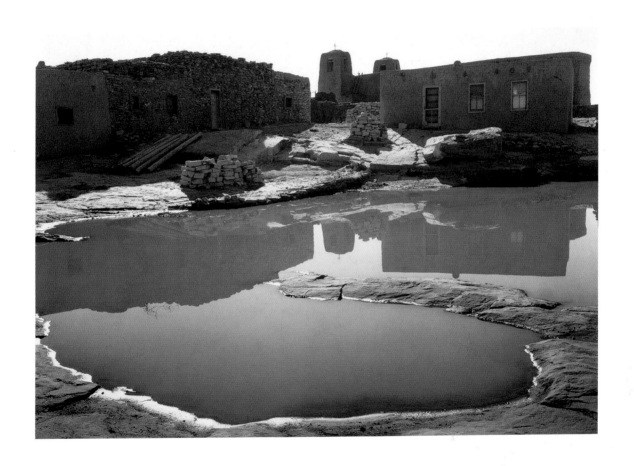

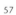

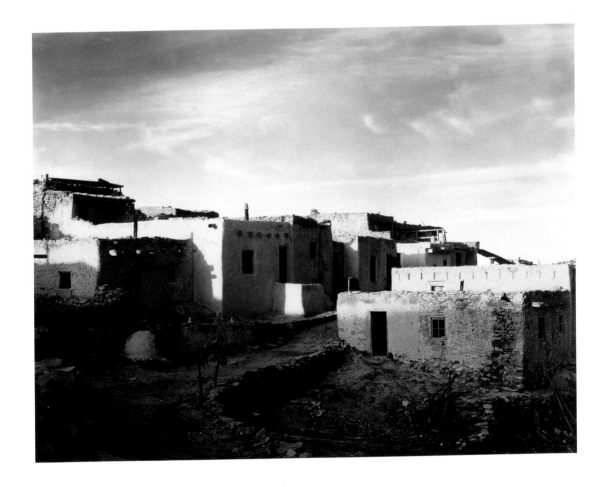

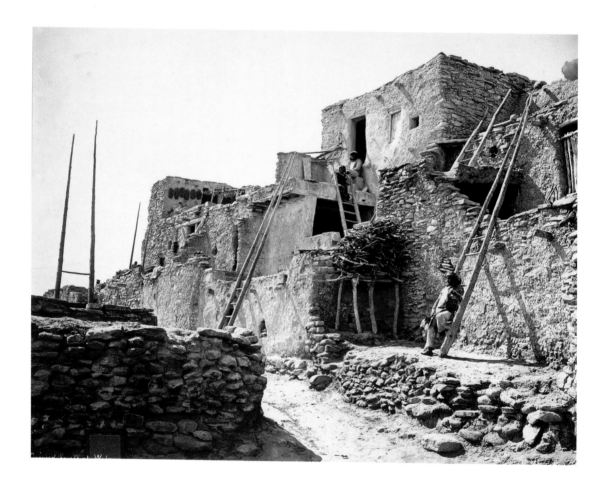

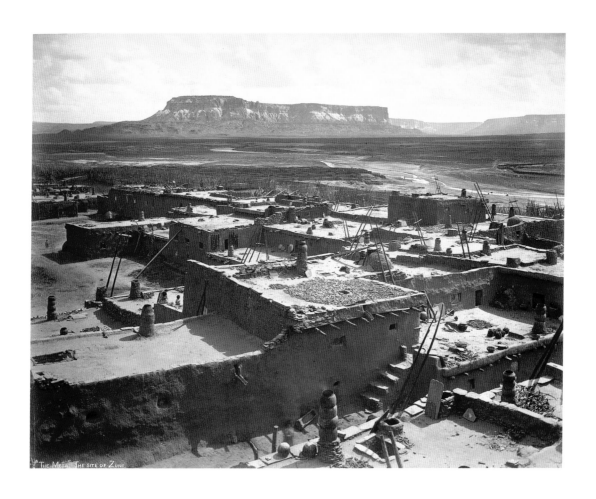

"The Mesa." The site of Zuni.

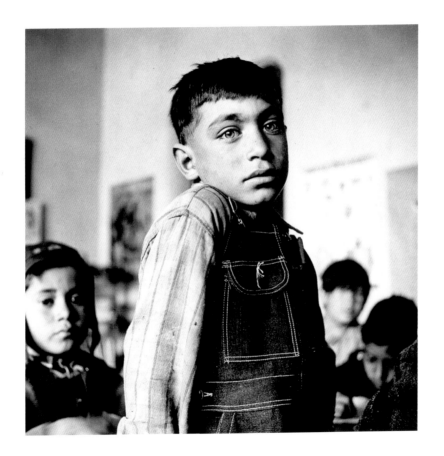

64

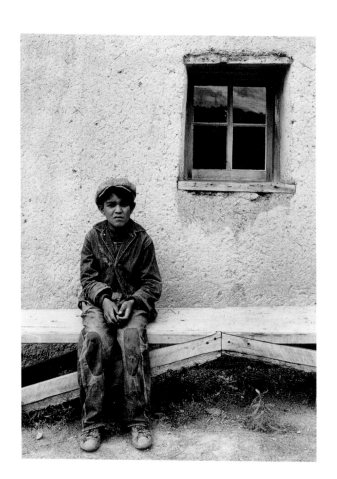

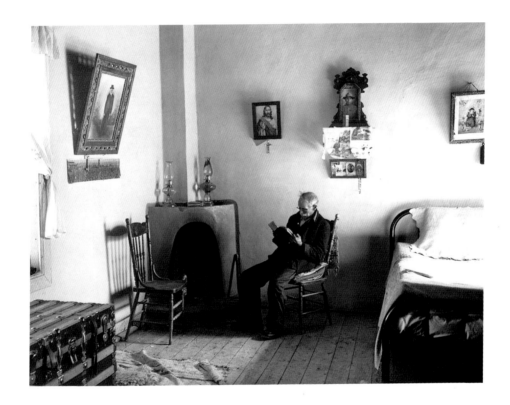

RUSSELL LEE, 1939
**DIRT FLOOR HOUSE, PIE TOWN, NEW MEXICO**
MUSEUM OF FINE ARTS, MUSEUM OF NEW MEXICO, 1990.70.71

66

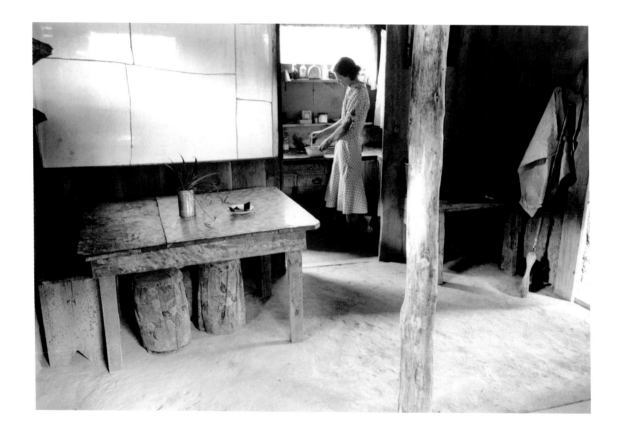

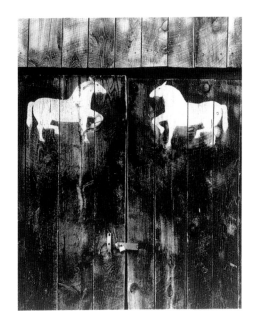

top/left
ANSEL ADAMS, 1951
**OLD WOODEN CROSS, TRAMPAS CHURCH,
NORTHERN NEW MEXICO**

top/right
ELIOT PORTER, 1961
**BARN DOORS, CUNIYO, NEW MEXICO**

below
LAURA GILPIN, 1961
**CAMPOSANTO EL VALLE, NEW MEXICO**

71

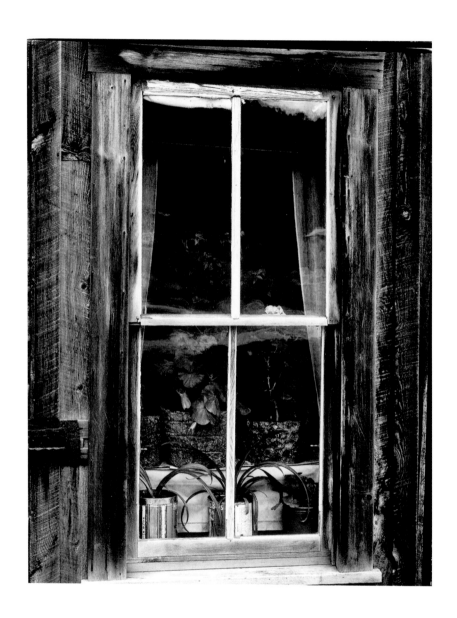

ANSEL ADAMS, CA. 1928–1929
**WINDOW AND DOOR,
NORTHERN NEW MEXICO**

below
ANSEL ADAMS, CA. 1950
**CROSSES, TRAMPAS, NEW MEXICO**

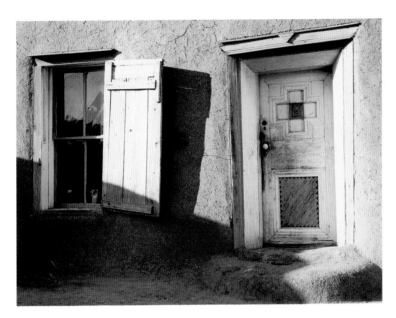

73

TODD WEBB, 1962
**GEORGIA O'KEEFFE'S PATIO DOOR,
ABIQUIU, NEW MEXICO**

right
ELIOT PORTER, 1949
**O'KEEFFE'S DOOR,
ABIQUIU, NEW MEXICO**

74

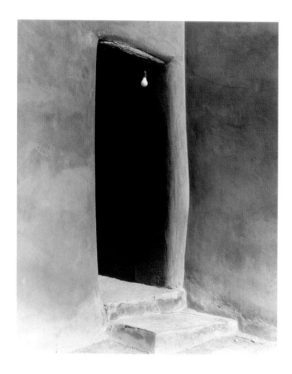

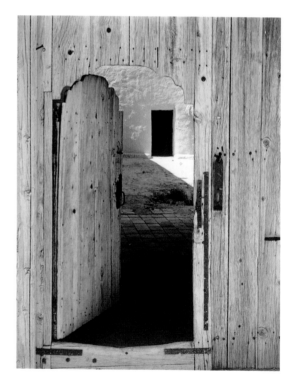

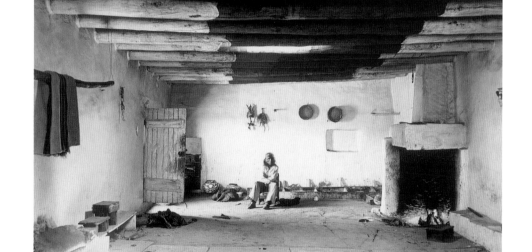

EDWARD S. CURTIS, 1925
**A PAGUATE ENTRANCE**

right
LAURA GILPIN, 1930
**PUEBLO INDIAN AND CORN,
NEW MEXICO**

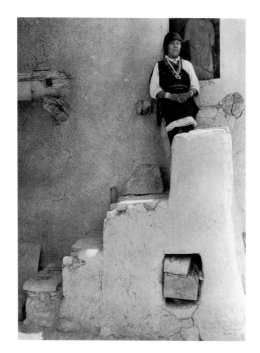

76

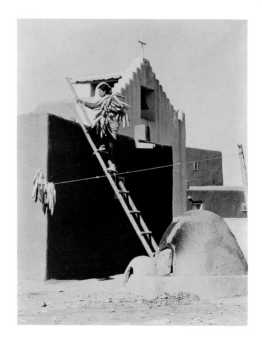

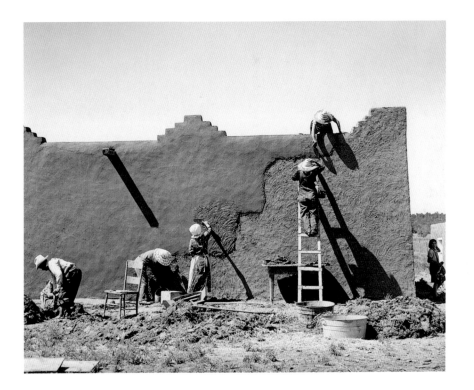

At the end of the nineteenth century, after photographers and painters had firmly established the Eden-like landscape of the Southwest in the imagination of the public, attention turned to an increased preoccupation with archaeological and ethnographic studies of the region and more frequent contact with the Pueblo and Spanish cultures. Adam Clark Vroman, a bookseller from Pasadena who was admired for his mastery of technique, produced picturesque representations of the Pueblo people for a number of years beginning in 1894. His interest was driven by a passion for preserving in images what he saw as the passing of a unique culture and way of life. With the establishment of the national park system, it had been demonstrated that photography could record, persuade, and perhaps change the course of history. In this vein he created unmanipulated images of the daily life of the Pueblo people. Unlike his predecessors, who had sought ways of heightening the drama of what they photographed, Vroman imposed only a minimal formal structure on a given scene, allowing the subject itself to produce the desired visual effect.

While Vroman's work remained stylistically reminiscent of the waning age of romanticism, it also heralded a new breed of artists who manifested empathy, rather than mystical idealism, for the

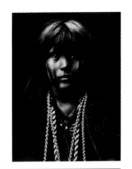

EDWARD S. CURTIS, 1903
**MOSA—MOHAVE**

region's native inhabitants. His work is remembered and appreciated for this crisp, lean vision, which is unique in its pictorial reserve.

In strong contrast to Vroman's modest, sensitive approach was that of Edward S. Curtis, who had the financial and political support of J. P. Morgan and Theodore Roosevelt. Photographing at the same time as Vroman, Curtis had a monumentally ambitious goal of attempting to photograph all North American tribes. Between 1898 and 1928 he produced forty thousand photographs, ten thousand sound recordings on wax cylinders, and twenty volumes of text encompassing eighty tribes. Although Curtis combined an ethnographic interest in the life and culture of Native Americans with personal aesthetic intentionality equal to that of the artists who preceded him, his vision was less progressive. His impressions of the landscape, often sentimental and romantic to an extreme, were rendered with deep shadows and theatrical lighting, while his portraits and environmental scenes were elegant, if idealized, representations reinforced by rhetorical claims of what he regarded as one of the greatest races of humankind. Curtis kept the torch of romanticism alive long after photography had begun to shed its pictorialist roots.

Curtis and Vroman represented opposite approaches and mixed motives that were characteristic of this transitional period wherein the perception of sublime landscape as nature unaccompa-

nied gave way to the realization of just how integrated were human elements to the whole. The evidence was not just in Native Americans' architecture and customs but in their faces, dress, and attitude. And as this wholeness—the land, sky, and all that is within—became more apparent to subsequent photographers, another realization grew that no matter how long they stayed collectively they possessed only an incomplete vision for representing the depth and breadth of the region. Each photographer in time added his special way of seeing to the lexicon of visual representations that attempted to reveal the elusive yet ever-present spirit of the region. By submitting to the subjectivity that stirred a constant desire to make images about the elemental nature of the Southwest, photographers were allowing their work to change, to become a part of "the thing itself."

When exploration per se was at an end and settlement meant exploitation of natural and human resources, the time ripened for artists who could see into both the past and the present. Early manifestations of modernism replaced romanticism as the prevalent artistic influence. Reconciliation of aesthetic issues with the hard reality of a growing population in the Southwest that was not indigenous to the region and did not share in its pictorial history became a difficult matter calling for new perspectives. By abstracting fragments of reality and presenting them as symbols for what

was desired from the past and for what could be seen as inspirational in the present, a new breed of photographer contributed to the continuum of images drawn from the spirit of the landscape.

In the twentieth century the long sought after paradise of the Southwest became a wish fulfilled, and apprehension of it in images encouraged a ravaging of its spiritual wholeness by tourism and rapidly expanding villages and towns. Paradise-realized quickly became paradise-forgotten, and it was not until a new wave of artists and preservationists in the 1920s reclaimed the region that the significance of its power over image-makers returned to public awareness, along with an expanded interest in all aspects of its unique qualities, including its wide range of inhabitants.

The nature of aesthetics and interest in the region by artists during the last twenty-five years has lessened and changed in concert with the agenda of postmodernism. This does not mean that landscape and aesthetically spiritual issues do not continue to affect some artists. Rather, as the fragmentation of cultural and artistic issues has increased in the last half of the twentieth century, it has become more difficult to observe the impact of the region itself on the arts, while the influence of earlier art and artists has become more apparent. Among contemporary artists whose vision of landscape and culture most reflects a continued fascination with the power and persuasion of place on

style and content is John Pfahl, whose landscape photographs are infused with contemporary context and philosophical issues. His artist's statement expresses an important aspect of the outgrowth of artistic attention given to any locale, especially the Southwest: "Some people think that the camera steals their soul. Places, I am convinced, are affected in the opposite way. The more they are photographed (or drawn and painted) the more soul they seem to accumulate . . . ; these places had become much more than their physical presence. They had become ideas."[13]

This statement about the transformation of a place from physical existence to idea goes to the heart of our discussion. When artists are acted upon by a region's special qualities and in turn produce works that are filtered through their specific visions with the intention of enhancing the "soul" of the region, the result is an object that trancends the realm of physical reality and becomes an abstraction, an imaginative stimulus, an idea that encompasses more of the essence of reality than can the chaos of reality itself.

When we speak of the "spiritual" nature of an artist's work, we do not refer to religious feeling as such, and yet no one would deny that something more than objective elements might be in play. In today's world the vocabulary that attempts to get at the heart of art is as convoluted and

disparate as the aftermath of postmodern society itself, and the notion of aesthetic elements as primary to image-making is a tough sell. Yet, it can be demonstrated that artists who have sensed the power of the places in which they work also allow and cultivate the spiritual character of such places in their work. The contemporary, postmodern art would, for example, suggest that there are "narrative" works, and I would say that such works are still "pictorial" no matter how aggravated the message or "naturalistic" the subject. It may be that form as a primary aesthetic tool has lost its shock value to contemporary eyes, but that is the nature of human nature, not evidence of progress in the arts. To the extent that early romantic artists and later the modernists sought reinforcement of the prevailing social code or reacted against it, the argument for art being driven more by social and cultural forces than purely aesthetic ones is reinforced. The modernist world, in which aesthetic form was isolated for its own sake, eventually ran amuck in a landscape of human concerns that could not segregate social relevance from social conscience, especially in the histrionics of art. Ironically, the spiritual qualities so often alluded to in the form of metaphor by modernist artists, whether philosophic or conceptual, were socially conscious statements expressive of their own time. By investing their very human passions and social views in the symbolism of elegant form, they were

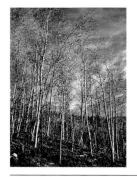

EDWARD WESTON, 1937
**ASPEN VALLEY, NEW MEXICO**

turning their backs on a world progressively deluding itself about reality. The discontent of intellectuals and artists of the first quarter of this century has been attributed to disillusionment with humanity following World War I. In the context of a disenfranchised art world moving toward Dadaism and Surrealism, the Stieglitz circle in photography is a prime example of the development of form-conscious tenets that came to be known as art for art's sake.

Although Edward Weston was not a member of the Stieglitz fold, they were friends and Weston was very much in tune with the developments of modernism that were manifest in Stieglitz's gallery and publications. In a set of notes for later transcription in his *Daybooks*, Weston wrote of Diego Rivera that he had "the humility that comes to those who, having confidence in their own worth, recognize the worth in others. Who, out of disillusionment, create beauty; out of human suffering, the future."[14] This reference to disillusionment, suffering, and the future represents the social consciousness inherent in the modernists mentioned above.

By the end of the century's second decade, the notion of the sublime in art was essentially abandoned. Religious and philosophic connotations in art were replaced by an interest in the self-consciousness of art itself, the bedrock of modernism. Of the many factors, including its European

sources, that fueled the modernist vision, the teaching of Arthur Wesley Dow at Columbia University had a major impact. Dow, one of the most influential educators of the period, studied in Europe and fused that experience with the growing influence of Japanese formalism on American art and design. In his own work this synthesis exhibited a more abstract result, and from his personal vision he developed the idea that art does not need to imitate nature but is a dialogue of abstract and formal issues between the artist and the act of making art. His ideas profoundly affected some of the major photographers and painters of the Southwest, including Alvin Langdon Coburn, Georgia O'Keeffe, and Max Weber, who, in turn, had a major impact on modernist photographers coming of age as mainstream artists in the formidable Photo-Secession group (1902–17) founded by Stiegtlitz. Weber's own work and his influential book, *Essays on Art*, published in 1916, expressed the core of modernist aesthetics. His ideas shifted the content of art from nature-inspired issues to a formal aestheticism in which the spirit of the artist was the guiding force in relation to objects, forms, and the structure of art itself.

Stieglitz, the most influential photographer in America from the turn of the century to mid-century, wrote, published, organized the Photo-secession movement, and operated galleries in New

York, through which he promoted a progression of ideas and aesthetics about modernism and philosophies of art for artists that had an impact throughout the country. His galleries—291–Little Galleries of the Photo-Secession, the Intimate Gallery, and American Place were what today we would call "artists' spaces." They were not commercial enterprises but experimental exhibition sites where contemporary artists found a forum and opportunities for influencing the public and art itself. Stieglitz introduced the first modernist artists from Europe (Rodin, Matisse, Picasso, Cézanne, and Brancusi) to America through his galleries and spearheaded the most effective efforts to have photography recognized for its own artistic merits. Through his own work he liberated photography from its narrative attachment to reality by revealing fragments of reality as symbols or metaphors for emotional and intellectual content, which, in turn, could more powerfully represent ideas about art, humanity, and the world than could its mere physical capture.

During this same period, artists, writers, and wealthy expatriates from the East Coast migrated to Taos, Santa Fe, and other cities of the region. America had found its own cultural mecca. The country without a classical past had discovered a citadel of antiquity that rivaled Europe in its architectural ruins of ancient Pueblo cultures, indigenous arts and crafts, and an aesthetic ambience

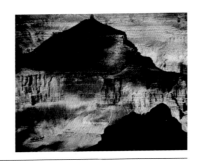

ALVIN L. COBURN, 1911
**THE GREAT TEMPLE,**
**GRAND CANYON, ARIZONA**

owing its unique character, in part, to continuing traditions stemming from the sixteenth-century Spanish conquest. Beginning with the Taos Colony, a loosely defined group of painters living and working in Taos in 1897, the migration of painters, writers, and photographers increased significantly for the next several decades, including distinguished figures such as Andrew Dasburg, John Sloan, Mabel Dodge Luhan, Mary Austin, D. H. Lawrence, Ansel Adams, Paul Strand, and Georgia O'Keeffe.

Out of the modernist tradition that found a strong foothold in the artists who came to the Southwest between 1900 and 1970 grew a new sense of what was required to reveal and sustain the essence of the region. From the atmospheric tableau of Alvin Langdon Coburn's photographs of the Grand Canyon in 1911 to Eliot Porter's selective colorations of New Mexico in the four decades following World War II, the modernist ideal for photography was the dominant aesthetic. Even when FSA photographers John Collier and Russell Lee brought their social documentary styles to the region in the 1940s, the formality of their works was dramatically different from the rawness of what they produced elsewhere. Among the photographs made in the region over the one hundred years considered here, their images of the indigent poor in Pie Town, New Mexico (Lee), and of Hispanic villagers in Truchas and Trampas (Collier) stand out in stark contrast to the predominant land-

scape interests of the majority of other photographers. Yet, there is in their photographs a common touch of the formal related to the modernist ideal of what constituted a work of art. Both Collier and Lee prided themselves on their "objective" means of photographing their subjects, but in these photographs from New Mexico the enviroment is inescapable and their visions are surely affected by awareness of the spirit of the region and the impact of its inhabitants.

The element of form as an overpowering aspect of photography in the Southwest, regardless of subject, is a reflection of the extent to which an environment so richly endowed with natural formations on a grand scale is able to condition even the most ardent visions of artists. Certainly the two most visually incisive form-conscious photographers of the Southwest would be Eliot Porter and Laura Gilpin, who endowed the landscape and its people with emotionally provocative images dependent upon the mastery of form and formal relationships of image construction. Porter's and Gilpin's passion and empathy for the eternal values inherent in the dignity and beauty of their subjects—land, sky, and all that is within—form a basic modernist intention to reveal the artists' own spiritual association with their subjects. At the same time both were products of their aesthetic heritage, which harkened back to early East Coast modernist influences. In his monograph of 1987,

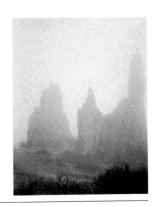

LAURA GILPIN, 1919
CATHEDRAL SPIRES, COLORADO

Porter wrote that Walker Evans was the photographer whom he most admired and that in the structure of Walker's images of the human scene he saw parallels to his own interests in nature. In short, Porter saw that the interrelationships of the human enterprise and those found in nature were both about the interrelationships of life.

Evans and Gilpin could easily have embraced, from their respective aesthetic persuasions, what Porter declared as the a priori element of photographs: "The essential quality of a photograph is the emotional impact that it carries, which is a measure of the author's success in translating into photographic terms his own emotional response to the subject."[15] This is the fundamental credo of the modernist who believes the spiritual resonance of the artist will be found in his or her subject, its form, and its essence.

Perhaps no photographer spoke more eloquently about the relationship of art to nature than Edward Weston, who also visited and photographed in the region during one of his Guggenheim trips. In a letter to Ansel Adams in 1932 he wrote the following: "I think first of all we must understand that Whistler was wrong—that nature does not imitate art, but the artist continually imitates nature even when he thinks he is is being 'abstract.'

"... We cannot imagine forms not already existing in nature—we know nothing else.

"... Actually, I have proven through photography, that nature has all the 'abstract' (simplified) forms, Brancusi or any other artist can imagine.

"... No—I don't want just seeing—but a presentation of the significance of facts, so that they are transformed from things (factually) seen, to things known; a revelation, so presented - wisdom controlling the means, the camera—that the spectator participates in the revelation."[16]

The most widely recognized photographer to photograph in the Southwest was Ansel Adams. To other artists his work expanded the visual language of fine prints and the interpretative power of photography. In the public's mind, second only to his beloved images of Yosemite are Adams's photographs of the Southwest. On several occasions, during the years of our friendship, he emphasized that the public did not understand that his photographs were abstractions of nature, not mirrors of reality-"A photograph is a simulation of a perception of the world around us-rather, of a fragment of this world selected from the universal chaos."[17] He often joked that God never went to art school.

Nature and reality were, in his view, potent symbols of existence waiting for conversion to aesthetic purposes. At the base of his artistic decisions, Adams's, like Porter's, was a preservationist's

heart. Out of art might come a heightened public conscience for the care and love of nature. In a letter to a friend, he wrote: "For me nature is an exalted symbol—not only in its grandiose appearances, but in minute and comprehensible realities of the immediate environment, the mood of sun and storm, and in the spaces between the touchable and the vastly remote."[18]

Each of the photographers mentioned in the foregoing text, who photographed in the Southwest, represents a much larger group included in the following plates. As described at the beginning of the essay, those included are selected because they represent either especially perceptive visual insights into the uniqueness of the region—its look and its feel—or because of the way in which the ubiquitous spirit of the landscape and all of its aspects significantly impacted their works. For some it actually changed the direction of their life and the aesthetic measure of their own visions. Adams, for example, saw Paul Strand's negatives in 1930 at Mabel Dodge Luhan's in Taos for the first time. That experience, as he related it to me in conversation fifty years later, was both about the extraordinary perception of Strand's vision and the almost magical luminosity of the light transmitted through his negatives, when Strand held them up to a window. He related how the light, atmosphere, and landscape of New Mexico and the region had their own qualities that were unforgettable and

unforgiving in their austerity and magnificence. Nancy Newhall said of Taos and Santa Fe that they were Adams's Rome and Paris and were to him a second home. [19]

In the final analysis, photographers who made images of the Southwest, particularly New Mexico, beginning in 1870 did so with a combination of aesthetic and social motives that continue to excite memories of its power and presence. Their images changed not only their artistic lives in some lasting way but change our lives too, by revealing the depth of our indebtedness to images of reality as conduits to the spiritual wholeness of the meaning of landscape and its inseparability from all that is within.

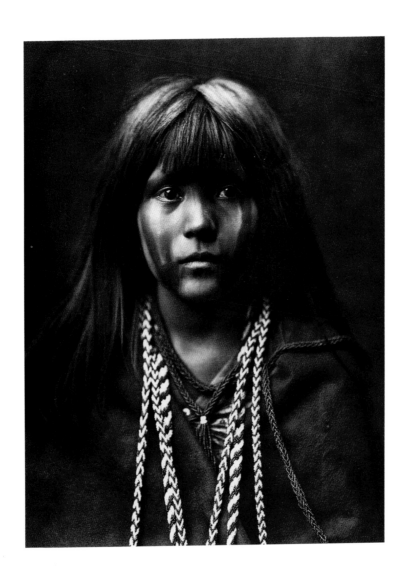

ANSEL ADAMS, CA. 1930
**ANTONIO LUJAN—TAOS PUEBLO, NEW MEXICO**

right
EDWARD S. CURTIS, 1905
**LAHLA (WILLOW), TAOS, NEW MEXICO**

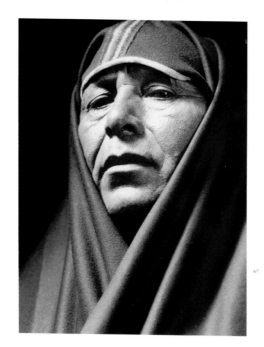

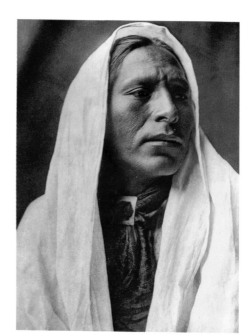

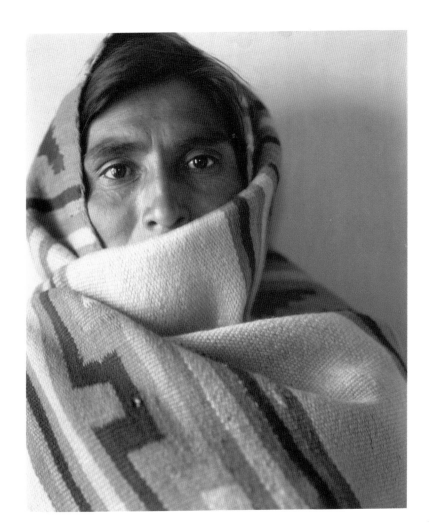

96

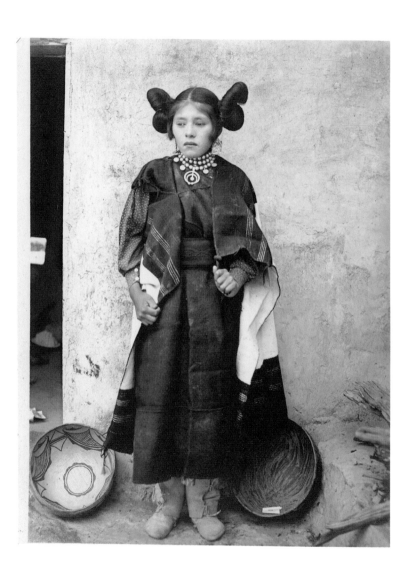

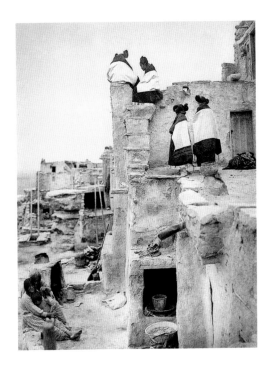

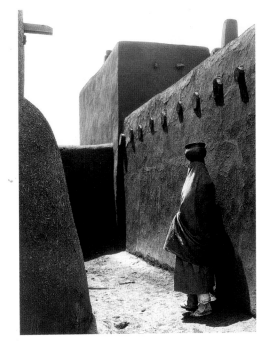

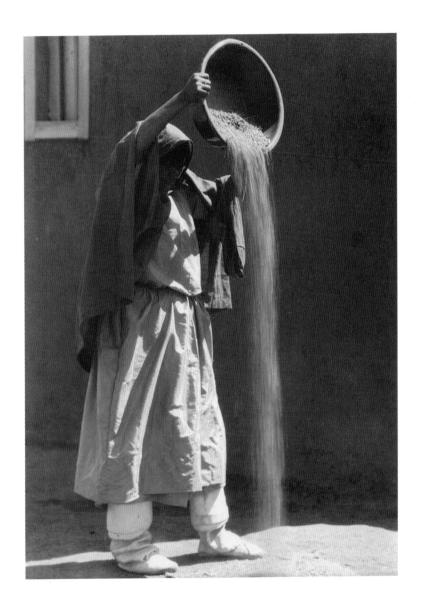

100

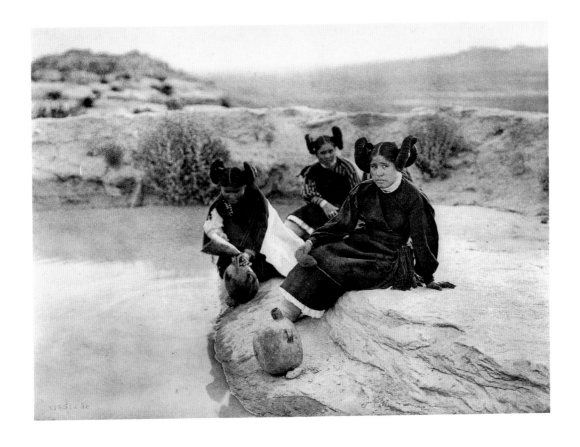

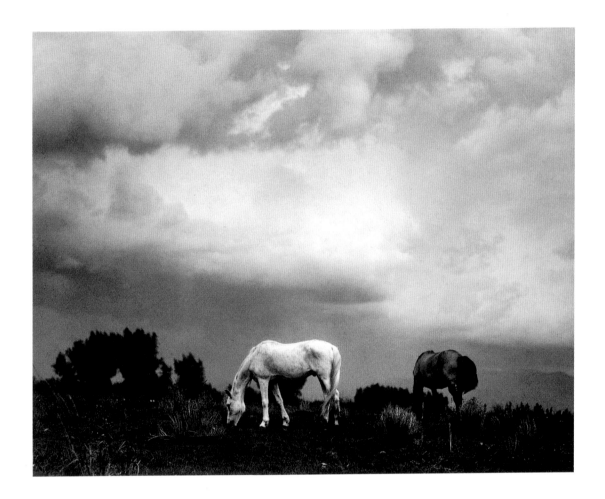

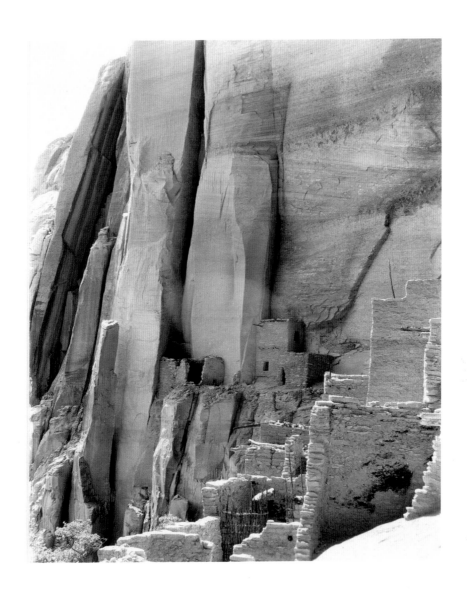

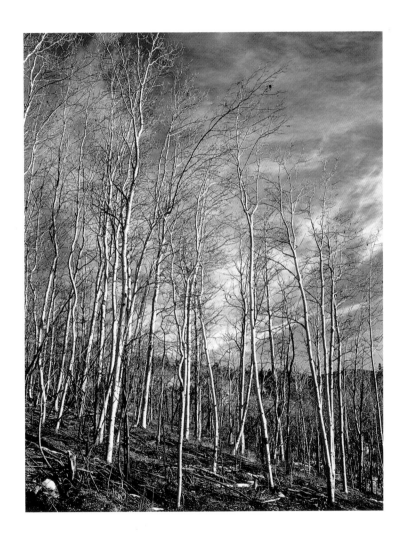

ANSEL ADAMS, 1958
**ASPENS, NEW MEXICO**
GEORGE EASTMAN HOUSE, 73:0063:0015

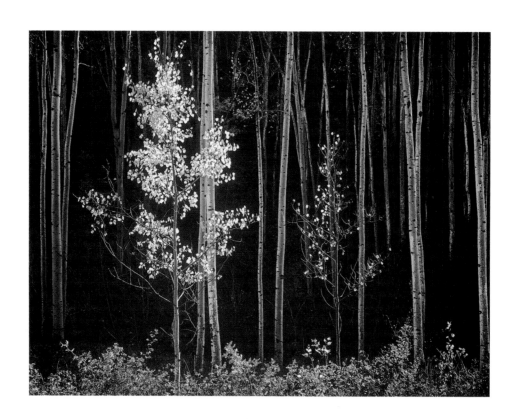

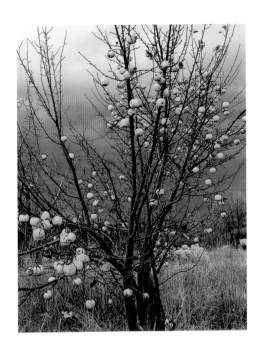

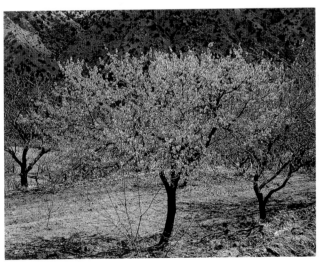

110

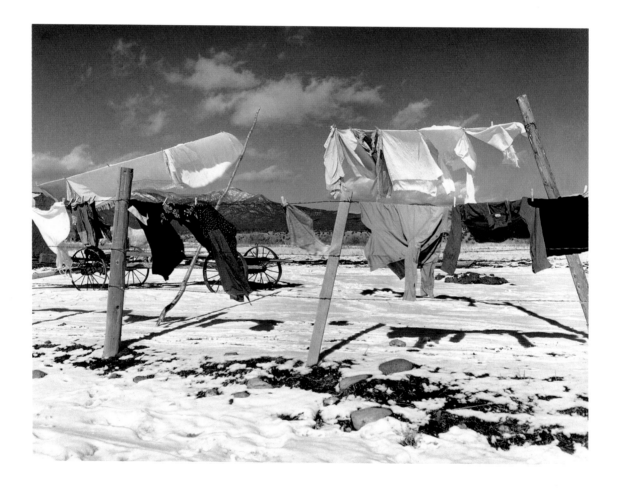

112

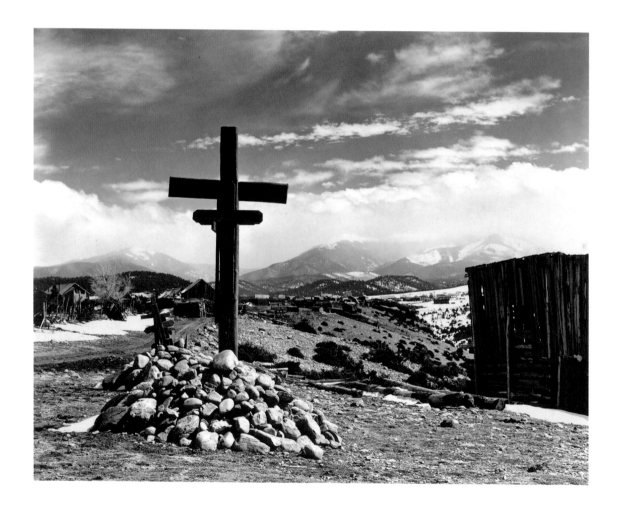

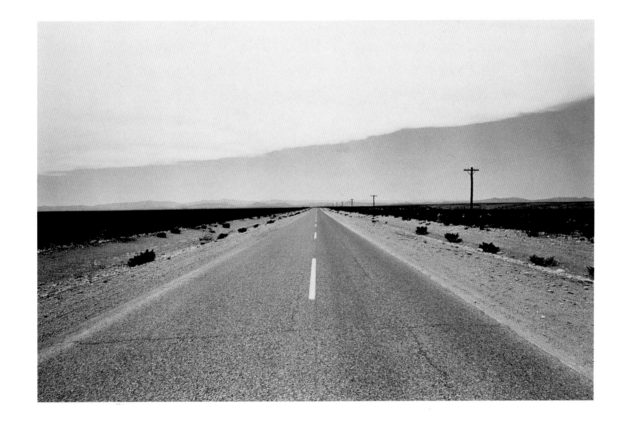

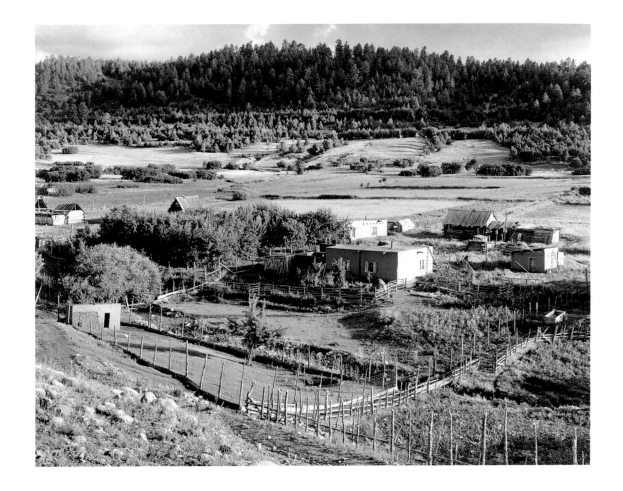

118

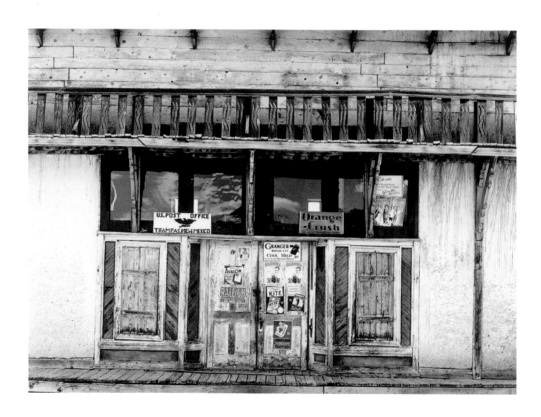

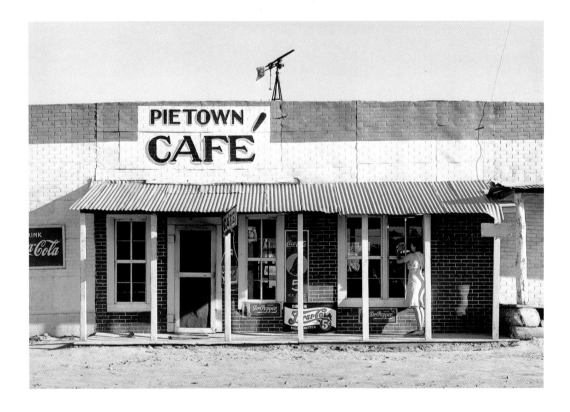

120

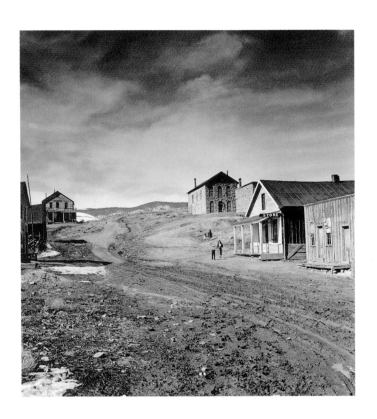

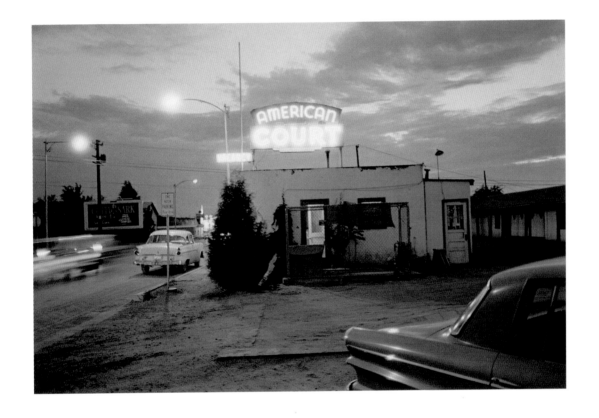

# Notes

1. The most useful and insightful book of this period in the history of photography is *The Rise of Landscape Photography in the American West, 1860–1885, Era of Exploration*, by Weston J. Naef, James N. Wood, and Therese Thau Heyman ( New York: Metropolitan Museum of Art in association with Albright-Knox Art Gallery, 1975). The authors' respective essays chronicle the photographic (especially technological), social, and cultural influences on five pivotal photographers: Carleton E. Watkins, Timothy H. O'Sullivan, Eadweard J. Muybridge, Andrew J. Russell, and William H. Jackson.

2. N. Scott Momaday, "Landscape with Words in the Foreground," in Judy Nolte Lensink, ed., *Old Southwest New Southwest: Essays on a Region and Its Literature* (Tucson: Tucson Public Library, 1987) 2.

3. Edward T. Hall, *The Hidden Dimension* (Garden City, NY: Anchor Books, Doubleday & Co. Inc., originally published 1966; this edition 1969) 81.

4. Etienne Gilson, *Painting and Reality* (Cleveland: Meridan; World Publishing Company, 1959) 177.

5. Arthur Schopenhauer, "The World as Will and Idea: Supplements to the First Book," in Albert Hofstadter and Richard Kuhns, eds. *Philosophies of Art and Beauty* (Chicago: University of Chicago Press, 1964) 451.

6. Ibid. 461.

7. Estelle Jussim, "Passionate Observer," in *A Distanced Land: The Photographs of John Pfahl* (Albuquerque: University of New Mexico Press in association with Albright-Knox Art Gallery, 1990) 2.

8. David Schuyler, "The Sanctified Landscape: The Hudson River Valley, 1820 to 1850," in George F. Thompson, ed., *Landscape in America* (Austin: University of Texas Press, 1995) 101.

9. William Wordsworth, "Lines Written in Early Spring," in Solomon Francis Gingerrich, ed., *Selected poems of William Wordsworth* (Boston: Houghton Mifflin Company, 1923) 3.

10. Joel Snyder and Doug Munson, *The Documentary Photograph as a Work of Art: American Photographs, 1860–1876* (Chicago: David and Alfred Smart Gallery, University of Chicago, 1976) 12.

11. Ibid.12.

12. Leslie Marmon Silko, "Landscape as Myth and Memory," in Thompson, *Landscape in America*, 157. The title of the current volume is drawn from Silko's description of landscape.

13. John Pfahl, *Permutations on the Picturesque* (Syracuse, NY: Light Work, No. 49. Syracuse University, 1997) 1.

14. This quote is taken from a set of notes written in December 1923 by Weston. The original notes are in the Edward Weston Archives at the Center for Creative Photography, University of Arizona, Tucson.

16. This quote is from a letter by Edward Weston to Ansel Adams dated January 1932. The original letter is in the Ansel Adams Archive at the Center for Creative Photography, University of Arizona, Tucson.

17. This conversation with Ansel Adams took place in the summer of 1978 in preparation for an introduction the author later wrote for an extensive transcript of a taped interview at the Bancroft Library, University of California, Berkely, October 1978.

15. Martha Sandweiss, foreword, *Eliot Porter* (Boston: New York Graphic Society, Little, Brown and Company, in association with the Amon Carter Museum, 1987) 86.

18. From a letter to Richard McGraw, 10 February 1957, Richard McGraw Archives, Center for Creative Photography, University of Arizona, Tucson.

19. Van Deren Coke, *Photography in New Mexico: From the Daguerreotype to the Present* (Albuquerque: University of New Mexico Press, 1979) 24.

ANSEL ADAMS, CA. 1928–1929
**WINDOW AND DOOR, NORTHERN NEW MEXICO**
GEORGE EASTMAN HOUSE 72:0065:0026

ANSEL ADAMS, CA. 1929
**NEW CHURCH, TAOS PUEBLO, NEW MEXICO**
GEORGE EASTMAN HOUSE, 72:0065:0002

ANSEL ADAMS, CA. 1929
**TAOS PUEBLO, NEW MEXICO**
CENTER FOR CREATIVE PHOTOGRAPHY, UNIVERSITY OF ARIZONA,
76.089.060

ANSEL ADAMS, CA. 1929
**WINNOWING GRAIN, TAOS PUEBLO, NEW MEXICO**
GEORGE EASTMAN HOUSE, 72:0065:0013

ANSEL ADAMS, CA. 1930
**ANTONIO LUJAN—TAOS PUEBLO, NEW MEXICO**
GEORGE EASTMAN HOUSE, 72:0065:0016

ANSEL ADAMS, CA. 1932
**REAR, RANCHOS DE TAOS CHURCH, NEW MEXICO**
GEORGE EASTMAN HOUSE, 67:0123:0025

ANSEL ADAMS, 1941
**MOONRISE OVER HERNANDEZ, NEW MEXICO**
MUSEUM OF FINE ARTS, MUSEUM OF NEW MEXICO, 82.13.1

ANSEL ADAMS, 1942
**ANTELOPE HOUSE RUIN**
GEORGE EASTMAN HOUSE, 74:0059:0002

ANSEL ADAMS, 1942
**CANYON DE CHELLY, ARIZONA**
GEORGE EASTMAN HOUSE, 73:0035:0002

ANSEL ADAMS, CA. 1942
**POOL, ACOMA PUEBLO, NEW MEXICO**
MUSEUM OF FINE ARTS, MUSEUM OF NEW MEXICO, 82.13.24

ANSEL ADAMS, 1942
**WHITE HOUSE RUIN, CANYON DE CHELLEY
NATIONAL MONUMENT**
MUSEUM OF FINE ARTS, MUSEUM OF NEW MEXICO, 82.13.23

ANSEL ADAMS, CA. 1950
**CROSSES, TRAMPAS, NEW MEXICO**
GEORGE EASTMAN HOUSE, 81:1029:0013

ANSEL ADAMS, CA. 1950
**PENITENTE MORADA, COYOTE, NEW MEXICO**
MUSEUM OF FINE ARTS, MUSEUM OF NEW MEXICO, 82.13.25

ANSEL ADAMS, 1951
**OLD WOODEN CROSS, TRAMPAS CHURCH, NORTHERN NEW
MEXICO**
GEORGE EASTMAN HOUSE, 72:0065:0036

ANSEL ADAMS, 1958
**ASPENS, NEW MEXICO**
GEORGE EASTMAN HOUSE, 73:0063:0015

ANSEL ADAMS, CA. 1958
**BULTO AND RETABLO, LAS TRAMPAS CHURCH, NEW MEXICO**
CENTER FOR CREATIVE PHOTOGRAPHY, UNIVERSITY OF ARIZONA,
76.083.089

ANSEL ADAMS, 1958
**MONUMENT VALLEY, UTAH**
GEORGE EASTMAN HOUSE, 72:0065:0053

ANSEL ADAMS, 1961
**THE GREAT PLAINS FROM CIMARRON, NEW MEXICO**
GEORGE EASTMAN HOUSE, 72:0065:0035

WILLIAM BELL, 1872
**GRAND CANYON**
GEORGE EASTMAN HOUSE, 80:0150:0012

WILLIAM BELL, 1872
**LOOKING SOUTH ACROSS THE GRAND CANYON, ARIZONA**
GEORGE EASTMAN HOUSE, 80:0151:0009

ALVIN L. COBURN, 1911
**GRAND CANYON, ARIZONA**
GEORGE EASTMAN HOUSE, 67:0157:0025

ALVIN L. COBURN, 1911
**THE GREAT TEMPLE, GRAND CANYON, ARIZONA**
GEORGE EASTMAN HOUSE, 77:0114:0028

ALVIN L. COBURN, 1912
**THE AMPHITHEATRE, GRAND CANYON, ARIZONA**
GEORGE EASTMAN HOUSE, 67:0157:0073

JOHN COLLIER, JR., 1942–1943
**ELISABETHTOWN, COLFER COUNTY, NEW MEXICO**
MUSEUM OF FINE ARTS, MUSEUM OF NEW MEXICO, 1990./70.315

JOHN COLLIER, JR., 1943
**A SANTO BULTO AND PAINTING OF THE DELAROSA, TRAMPAS, NEW MEXICO**
MUSEUM OF FINE ARTS, MUSEUM OF NEW MEXICO, 1990.70.280

JOHN COLLIER, JR., 1943
**CLOTHES LINE, PENASCO, NEW MEXICO**
MUSEUM OF FINE ARTS, MUSEUM OF NEW MEXICO, 1990.70.268

JOHN COLLIER, JR., 1943
**FATHER CASSIDY HELPS FIX A CAR, NEW MEXICO**
MUSEUM OF FINE ARTS, MUSEUM OF NEW MEXICO, 1990.70.263

JOHN COLLIER, JR., 1943
**GRANDFATHER ROMERO, TRAMPAS, NEW MEXICO**
MUSEUM OF FINE ARTS, MUSEUM OF NEW MEXICO, 1990.70.304

JOHN COLLIER, JR., 1943
**RANCHO DE TAOS, NEW MEXICO**
MUSEUM OF FINE ARTS, MUSEUM OF NEW MEXICO, 1990.70.204

JOHN COLLIER, JR., 1943
**SCHOOL, QUESTA, NEW MEXICO**
MUSEUM OF FINE ARTS, MUSEUM OF NEW MEXICO, 1990.70.301

JOHN COLLIER, JR., 1943
**TRAMPAS, NEW MEXICO**
MUSEUM OF FINE ARTS, MUSEUM OF NEW MEXICO, 1990.70.281

EDWARD S. CURTIS, 1903
**MOSA—MOHAVE**
UNIVERSITY OF NEW MEXICO ART MUSEUM, 73.104

EDWARD S. CURTIS, 1905
**LAHLA (WILLOW), TAOS, NEW MEXICO**
UNIVERSITY OF NEW MEXICO ART MUSEUM, 73.106

EDWARD S. CURTIS, 1906
**CANYON DEL MUERTO—NAVAHO**
UNIVERSITY OF NEW MEXICO ART MUSEUM, 73.125

EDWARD S. CURTIS, 1906
**EVENING IN HOPI LAND**
UNIVERSITY OF NEW MEXICO ART MUSEUM, 73.124

EDWARD S. CURTIS, 1921
**ON THE HOUSETOP**
UNIVERSITY OF NEW MEXICO ART MUSEUM, 73.109

EDWARD S. CURTIS, 1925
**A PAGUATE ENTRANCE**
UNIVERSITY OF NEW MEXICO ART MUSEUM, 73.113

LAURA GILPIN, 1919
**CATHEDRAL SPIRES, COLORADO**
CENTER FOR CREATIVE PHOTOGRAPHY, UNIVERSITY OF ARIZONA, 77.023.002

LAURA GILPIN, 1930
**BRYCE CANYON, UTAH**
CENTER FOR CREATIVE PHOTOGRAPHY, UNIVERSITY OF ARIZONA, 77.023.013

LAURA GILPIN, 1930
**CLIFF DWELLING OF BETATAKIN, ARIZONA**
UNIVERSITY OF NEW MEXICO ART MUSEUM, 73.224

LAURA GILPIN, 1930
**PUEBLO INDIAN AND CORN, NEW MEXICO**
MUSEUM OF FINE ARTS, MUSEUM OF NEW MEXICO, 82.12.2

LAURA GILPIN, 1930
**RANCHO DE TAOS, NEW MEXICO**
CENTER FOR CREATIVE PHOTOGRAPHY, UNIVERSITY OF ARIZONA, 77.071.007

LAURA GILPIN, 1931
**SPIRIT OF THE PRAIRIE**
MUSEUM OF FINE ARTS, MUSEUM OF NEW MEXICO, 82.12.3

LAURA GILPIN, 1932
**THE LITTLE MEDICINE MAN**
CENTER FOR CREATIVE PHOTOGRAPHY, UNIVERSITY OF ARIZONA, 77.023.003

LAURA GILPIN, 1934
**NAVAJOS BY FIRELIGHT**
MUSEUM OF FINE ARTS, MUSEUM OF NEW MEXICO, 88.066.9

LAURA GILPIN, 1946
**THE "HE" RAIN STORM**
MUSEUM OF FINE ARTS, MUSEUM OF NEW MEXICO, 81.12.14

LAURA GILPIN, 1946
**THUNDERSTORM FROM LA BAJADA**
UNIVERSITY OF NEW MEXICO ART MUSEUM, 71.4

LAURA GILPIN, 1961
**CAMPOSANTO EL VALLE, NEW MEXICO**
UNIVERSITY OF NEW MEXICO ART MUSEUM, 66.221

LAURA GILPIN, 1961
**PICURIS CHURCH, NEW MEXICO**
MUSEUM OF FINE ARTS, MUSEUM OF NEW MEXICO, 80.15.1

JOHN K. HILLERS, 1873
**PARUNUWEAP CANYON, VIRGIN RIVER VALLEY, UTAH**
GEORGE EASTMAN HOUSE, 81:0961:0004

JOHN K. HILLERS, 1875
**MOUNTAIN LAKE**
GEORGE EASTMAN HOUSE, 70:0148:0008

JOHN K. HILLERS, CA. 1875
**CAÑON DE CHELLEY, ARIZONA**
GEORGE EASTMAN HOUSE, 81:0961:0002

JOHN K. HILLERS, CA. 1875
**GRAND CANYON**
UNIVERSITY OF NEW MEXICO ART MUSEUM, 72.372

JOHN K. HILLERS, CA. 1875
**GRAND CANYON, ARIZONA**
GEORGE EASTMAN HOUSE, 81:0958:0001

JOHN K. HILLERS, CA. 1875
**MARBLE CAÑON, COLORADO RIVER**
GEORGE EASTMAN HOUSE, 81:0957:0001

JOHN K. HILLERS, CA. 1875
**ZUNI PUEBLO**
GEORGE EASTMAN HOUSE, 70:0148:0006

JOHN K. HILLERS, 1879
**TERRACED HOUSES AT WOLPI**
UNIVERSITY OF NEW MEXICO ART MUSEUM, 68.20

WILLIAM H. JACKSON, CA. 1870–1875
**GLEN EYRIE, COLORADO SPRINGS, COLORADO**
UNIVERSITY OF NEW MEXICO ART MUSEUM, 77.147

RUSSELL LEE, 1939
**DIRT FLOOR HOUSE, PIE TOWN, NEW MEXICO**
MUSEUM OF FINE ARTS, MUSEUM OF NEW MEXICO, 1990.70.71

RUSSELL LEE, 1940
**CAFÉ, PIE TOWN, NEW MEXICO**
MUSEUM OF FINE ARTS, MUSEUM OF NEW MEXICO, 1990.70.161

RUSSELL LEE, 1940
**CATRON, NEW MEXICO**
MUSEUM OF FINE ARTS, MUSEUM OF NEW MEXICO, 1990.70.131

RUSSELL LEE, 1940
**LLANO DE SAN JUAN, NEW MEXICO**
MUSEUM OF FINE ARTS, MUSEUM OF NEW MEXICO, 1990.70.191

RUSSELL LEE, 1940
**STUCCOING WALL, CHAMISAL, NEW MEXICO**
MUSEUM OF FINE ARTS, MUSEUM OF NEW MEXICO, 1990.70.185

TIMOTHY H. O'SULLIVAN, 1873
**CAÑON DE CHELLEY, ARIZONA**
GEORGE EASTMAN HOUSE, 79.0014:0041

TIMOTHY H. O'SULLIVAN, 1873
**CANYON DE CHELLEY, ARIZONA**
GEORGE EASTMAN HOUSE, 79:0014:0051

TIMOTHY H. O'SULLIVAN, 1873
**OLD MISSION CHURCH, ZUNI PUEBLO, NEW MEXICO**
GEORGE EASTMAN HOUSE, 79:0014:0058

TIMOTHY H. O'SULLIVAN, 1874
**THE COLORADO RIVER AT THE MOUTH OF PARIA CREEK**
GEORGE EASTMAN HOUSE, 79:0014:0043

ELIOT PORTER, 1940
**ALAMAGORDO, NEW MEXICO**
MUSEUM OF FINE ARTS, MUSEUM OF NEW MEXICO, 85.288.3

ELIOT PORTER, 1940
**CHURCH OF CORDOVA, NEW MEXICO**
MUSEUM OF FINE ARTS, MUSEUM OF NEW MEXICO, 82.16.7

ELIOT PORTER, 1940
**CROSS, TRUCHAS, NEW MEXICO**
MUSEUM OF FINE ARTS, MUSEUM OF NEW MEXICO, 85.242.1

ELIOT PORTER, 1940
**ORTIZ MOUNTAINS, NEW MEXICO**
MUSEUM OF FINE ARTS, MUSEUM OF NEW MEXICO, 86.143.2

ELIOT PORTER, 1940
**POST OFFICE, TRAMPAS, NEW MEXICO**
MUSEUM OF FINE ARTS, MUSEUM OF NEW MEXICO, 84.594.11

ELIOT PORTER, 1940
**TRUCHAS, NEW MEXICO**
MUSEUM OF FINE ARTS, MUSEUM OF NEW MEXICO, 84.594.14

ELIOT PORTER, 1948
**BLACK MESA, NEW MEXICO**
SCHEINBAUM AND RUSSEK, 810-48-16

ELIOT PORTER, 1948
**NEAR MULE CREEK, NEW MEXICO**
MUSEUM OF FINE ARTS, MUSEUM OF NEW MEXICO, 86.207.1

ELIOT PORTER, 1949
**O'KEEFFE'S DOOR, ABIQUIU, NEW MEXICO**
MUSEUM OF FINE ARTS, MUSEUM OF NEW MEXICO, 86.489.2

ELIOT PORTER, 1950
**POJOAQUE VALLEY, NEW MEXICO**
MUSEUM OF FINE ARTS, MUSEUM OF NEW MEXICO, 84.594.4

ELIOT PORTER, 1953
**CANYON DE CHELLEY, ARIZONA**
MUSEUM OF FINE ARTS, MUSEUM OF NEW MEXICO, 1992.21.09

ELIOT PORTER, 1960
**PEACH TREE, CHIMAYO, NEW MEXICO**
SCHEINBAUM AND RUSSEK, 60-22

ELIOT PORTER, 1961
**BARN DOORS, CUNIYO, NEW MEXICO**
MUSEUM OF FINE ARTS, MUSEUM OF NEW MEXICO, 85.440.1

ELIOT PORTER, 1961
**CHAIR AND WINDOW, TESUQUE, NEW MEXICO**
MUSEUM OF FINE ARTS, MUSEUM OF NEW MEXICO, 84.594.2